SHAPES
OF POWER,
BELIEF AND
CELEBRATION

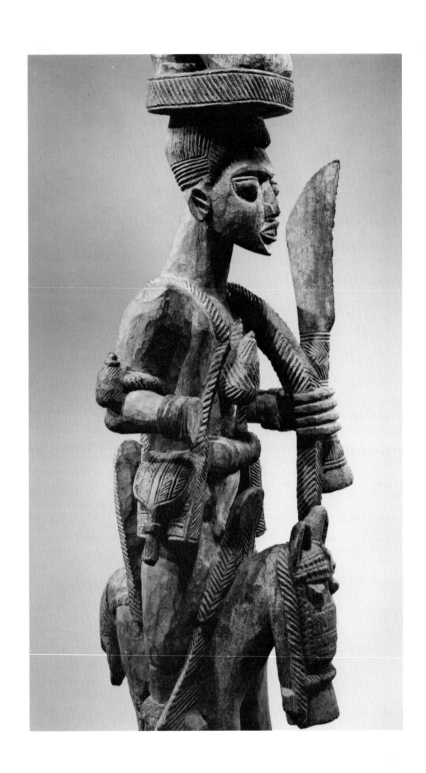

SHAPES OF POWER, BELIEF AND CELEBRATION

African Art from New Orleans Collections

William A. Fagaly

New Orleans Museum of Art

1989

This publication and the exhibition it accompanies are supported in part by grants from the Louisiana Endowment for the Humanities, the state affiliate of the National Endowment for the Humanities, and Bill Watson Ford/Bill Watson Hyundai, New Orleans.

Dedicated to the memory of Peggy Stoltz Gilfoy (1936-1988) and Arnold Gary Rubin (1937-1988)

2000 copies of this catalogue were printed for the exhibition
Shapes of Power, Belief and Celebration:
African Art from New Orleans Collections.

Library of Congress Catalogue Card Number: 89-060387.
ISBN: 0-89494-028-7

Exhibition Schedule:

New Orleans Museum of Art
New Orleans, Louisiana
March 11-April 16, 1989

University Art Museum
University of Southwestern Louisiana
Lafayette, Louisiana
June 3-July 23, 1989

Meadows Museum of Art at Centenary College
Shreveport, Louisiana
September 10-November 12, 1989

Front Cover: Djenné Culture, Mali, Standing Figure of a Ewe no. 3 (detail)
Bamileke Peoples, Cameroon, Headcrest no. 95
Frontispiece: Yoruba Peoples, Olowe of Ise, carver, Nigeria,
Veranda Post no. 75 (detail)

Designed by Ed Biggs, New Orleans
Catalogued artwork photographed by Pierre de La Barre, New Orleans
Photographs of catalogued artwork printed by Greg Simms, New Orleans
Typeset by Green's Typographic Service, New Orleans
Printed by Moran Colorgraphic, Baton Rouge

All dimensions are inches, height preceding width preceding depth, followed by metric equivalents in parentheses. The catalogue is divided into four major geographic sections. Within each section, objects from the same culture are grouped together.

Contents

Preface

The New Orleans Museum of Art is proud of its record of recognizing the achievements of the artists of tribal Africa. The first exhibition focusing on these cultures, *Spotlight on Africa*, was held at the Museum in 1952 followed three years later by a presentation of the famed Helena Rubenstein collection of African sculpture. The Museum's Fiftieth Anniversary exhibition in 1961, *Masks and Masquerades*, devoted a section to African works. In 1966, at a time when few American art museums had made a commitment to the permanent display of African art, the New Orleans Museum inaugurated an African gallery to exhibit its few holdings along with an extraordinary group of objects placed on extended loan by Mr. and Mrs. Frederick M. Stafford of Paris and New York. In 1968 the Museum organized the exhibition and published the accompanying catalogue *New Orleans Collects: African Art*. That same year the Museum presented an exhibition assembled by the Museum of Fine Arts in Houston of Benin bronzes. The outstanding Lester Wunderman collection of Dogon art (1973); one-hundred masterworks from the national collections of Zaire (1978); the art of Cameroon (1984) and Shoowa raffia textiles from Zaire (1988) were among the highlights of the special exhibitions shown here during the past fifteen years.

The Museum's permanent collection of African art had an auspicious beginning — the anonymous gift in 1953 of a late 18th-century cast copper alloy *Head of an Oba*, from the Kingdom of Benin in Nigeria. To inaugurate the three new wings to NOMA in 1971, one of the great masterpieces of African art was purchased for the collection with funds from the Ella West Freeman Foundation Matching Fund: a veranda post of a mounted warrior by the master Yoruba carver Olowe of Ise. Carved for the palace of the Ogoga at Ikere in Yorubaland, this monumental work set the highest standard of quality for future acquisitions.

The acceleration of exhibitions and acquisitions of African art during the past two decades has been the direct result of the activities of NOMA's Curator of Ethnographic Art, William A. Fagaly, who joined the staff in 1966 and currently serves as well as Assistant Director for Art. Trained at Indiana University under Professor Roy Sieber, Bill's broad knowledge and keen connoisseurship has provided the Museum and private collectors in New Orleans with an unmatched resource of expertise and enthusiasm.

To date, the most significant donation to NOMA's Africa collection was the group of one hundred forty magnificent African works bequeathed in 1977 by Victor K. Kiam, along with major paintings and sculptures by Miró, Picasso, Giacometti and Dubuffet. Two of New Orleans' most prominent contemporary artists, Ida Kohlmeyer and the late Robert Gordy, have stated that they have drawn inspiration from the African art they collect. Bob Gordy's bequest of his entire collection to the Museum in 1987 further strengthened the Museum's holdings.

Instrumental in the recent development of many private collections of African art in New Orleans has been the presence in the city for the past fifteen years of the Davis Gallery. By presenting superb and rare pieces, Kent and Charles Davis have rapidly established their gallery as one of the best in the country, supplying major art museums and private collectors.

Shapes of Power, Belief and Celebration: African Art from New Orleans Collections is a testament to New Orleanians' devotion to the art of tribal Africa. The Museum is pleased to acknowledge and celebrate that interest and commitment, which can only grow and prosper in the future.

E. John Bullard
Director

Acknowledgments

Exhibitions are the result of the involvement and cooperation of many persons, each deserving recognition for their contributions. This exhibition was suggested first by Director John Bullard. I am grateful for his continued interest and support of this project. Needless to say, the exhibition would not exist without the generous participation of the collectors who unselfishly have made their cherished objects available. Although their names are recorded on the lenders' page, I wish also to express my gratitude to them here.

I am pleased to have received generous support from the Louisiana Endowment for the Humanities for the publication of this catalogue. My sincere thanks go to Bill and Richard Watson of Bill Watson Ford/Bill Watson Hyundai, who have been supportive, and as corporate sponsor of the exhibition, have underwritten a portion of the necessary expenses. I am appreciative to all those individuals and groups who generously contributed monies for the purpose of providing matching funds for the LEH grant. They are Dr. H. Russell Albright, Barbara and Wayne Amedee, Katherine and Richard Buckman, Minnie and James Coleman, Jr., Kent and Charles Davis, Dr. John Finley, Renna and John Godchaux, Dr. and Mrs. George Harell, Ida and Hugh Kohlmeyer, Mr. and Mrs. J. Thomas Lewis, Jane and Henry Lowentritt, Mayer-Katz Foundation, Michael Myers, Pace Gallery, Polly and Edward Renwick, Françoise Billion Richardson, Simms Fine Arts, Nancy Stern, Kathe and Bill Watson and Joni and Richard Watson.

New information is continually coming to light in the study of African art, and I thank those scholars who provided the latest available data. Responding graciously to my inquiries were Marie-Thérèse Brincard, Henry Drewel, Kate Ezra, William Fagg, Keith Nicklin, Robin Poyner, Philip Ravenhill, Doran Ross, Roy Sieber, William Siegmann, Roslyn Walker and Hermione Waterfield. Both Charles Davis and Marc Felix also supplied indispensable information on specific works and Joseph Powell cheerfully performed other research chores.

For the production of the catalogue, I acknowledge the invaluable assistance I have received from all those persons involved. Firstly, photographer Pierre de La Barre provided beautiful images of the objects. I am grateful to him and to Charles Davis who generously has given valuable advice during the lengthy shooting schedule. The additional photographic assistance received from Greg Simms proved invaluable. Paul Tarver, Curator of Traveling Exhibitions, skillfully engineered the complicated arrangements with the lenders for the photography of objects. I am indebted to Darrell Brown, Curatorial Assistant, for handling the myriad details concerning the manuscript preparation. Both Sharon Litwin, Assistant Director for Development, and Carl Penny, Librarian, kindly edited the catalogue text. The commitment and dedication of designer Ed Biggs has resulted in this handsome catalogue.

Registrar Daniel Piersol has performed his duties processing the loans with his usual efficiency and dispatch. Curator of Exhibitions Valerie Olsen and Chief Preparator Thom Herrington and his staff demonstrated their ready willingness and dedication in the beautiful installation of the exhibition under difficult handicaps. Following its viewing in New Orleans, *Shapes of Power, Belief and Celebration* will be presented in Lafayette and Shreveport, Louisiana. It has been a pleasure to work with Directors Herman Mhire of the University Art Museum, University of Southwestern Louisiana and Judy Godfrey at the Meadows Museum of Art at Centenary College. Finally, I would not have been able to successfully complete this project without the support and assistance I continue to receive from my secretary Anne Bittel. For her participation and all those others I offer my heartfelt thanks and deep appreciation.

Wiliiam A. Fagaly
Assistant Director for Art
Curator of Ethnographic Art

Lenders to the Exhibition

Dr. H. Russell Albright

Barbara and Wayne Amedee

Drs. Jane and William Bertrand

Dr. and Mrs. Raoul Bezou

Princess Yashodhara and Dr. Siddharth Bhansali

Katherine and Richard Buckman

E. John Bullard

Minnie and James Coleman, Jr.

Kent and Charles Davis

Dr. John Finley

Luba B. Glade

Renna and John Godchaux

Carol and Dr. George Harell

Ida and Hugh Kohlmeyer

Mr. and Mrs. Pierre de La Barre

Mr. and Mrs. J. Thomas Lewis

Jane and Henry Lowentritt

Dorothy Mahan

Alice Mayer-Katz, Dr. Walda Katz-Fishman,
 and Judge and Mrs. Robert A. Katz

Mayer-Katz Foundation

Allison and Kenneth McAshan

Justine and Richard McCarthy

Michael Myers

Mrs. P. Roussel Norman

Vernon Palmer

Joseph Powell

Polly and Edward Renwick

Françoise Billion Richardson

Mr. and Mrs. Robert Billion Richardson

Nancy Stern

Kathe and Bill Watson

Joni and Richard Watson

Ann Wilkinson

Gene Willett

and Anonymous Lenders

Introduction

African art in its broadest sense includes not only sculpture, but music, dance, drama, textiles, body painting and scarification. For this exhibition the focus is on the sculptural objects, including architectural parts and utilitarian articles, of the principal art-producing peoples living south of the Sahara Desert. This vast area from Senegal to Zaire is a region of diverse climatic conditions and land types inhabited by a multitude of distinct tribal groups (figure 1). Forming a wide band running through the midcontinent, it is characterized by four general zones: the arid desert and sparse, grassy plains of the Western Sudan; the hilly woodlands of the Guinea Coast; the dense tropical rain vegetation of the mountainous Equatorial Forest; and the spacious, open grasslands of the Southern Savannah. The diversity of sculptural styles is as great as the many language groups and cultures in this broad area.

Figure 1

The Study of African Art

The experience of art in western cultures does not prepare one necessarily to understand the role of art and the artist in African societies. Wrought from a different kind of social experience, the language of African art is alien. Its message is aimed at people from another cultural environment. To encounter African art as more than exotic curiosity, one must learn to see in a different way and to hear a different message.

The history of sub-Saharan Africa is difficult to reconstruct since written records do not exist. In their absence, the Africans have depended on a strong oral tradition passed on from generation to generation. Lengthy chronological listings of tribal rulers and complex tribal migration patterns have been transmitted for centuries, seemingly with a high degree of accuracy, just by word of mouth. Even though they gennerally showed little or no interest in the Africans' artistic endeavors, it is helpful to consult the documented accounts of early European travelers such as explorers, traders and missionaries, who visited the continent and occasionally described objects and events of aesthetic value. Some acculturation has occurred however.

Ivory saltcellars and other utilitarian objects were carved in the fifteenth and sixteenth centuries by the Africans for European usage (figure 2). These rare and intricate carvings, known as Afro-Portuguese ivories, are clearly European in form but African in style. Conversely, Africans have adapted European forms for their own purposes such as the Tshokwe chair *no. 129* and the Kongo crucifix *no. 112*.

Figure 2

Archaeological excavation is another method of retrieving historical information. The recovery of art objects made of non-perishable materials such as metal, stone and terracotta has revealed a little concerning the aesthetics of early Africans. However, often lacking sufficient operational funding, few modern excavations are conducted under properly controlled scientific conditions. Thus, while the number of artistic treasures is increasing, missing is the vital and enlightening contextual data about the living patterns and beliefs of the peoples who made them. Combined with the information obtained from early European sources and oral histories of Africa, the knowledge gleaned from the objects discovered through this limited archaeological means is slowly assisting in reconstructing the history of older African civilizations and their artistic output.

Early Sculptural Traditions

The earliest examples of a sculptural tradition from sub-Saharan Africa known today were discovered accidentally in 1943 in Nigeria on the Jos Plateau where deep tin-mining operations were underway. The meaning and usage of these Nok culture terracotta figures (figure 3), dating at least from the middle of the first millennium B.C., is not clear; however it is suspected they were ancestoral or commemorative in nature.

Around the same time as the discovery of the Nok terracottas, another archaeological excavation in Nigeria, called Igbo-Ukwu, uncovered the burial chamber of a person of great importance wearing ceremonial dress and surrounded by symbols of his authority. This site, dating from the ninth century A.D., revealed the earliest known sub-Saharan art objects cast by the sophisticated lost-wax process in which melted beeswax is replaced by molten metal in a clay mold. These intricately executed works demonstrate a complete mastery of this technically difficult method of casting metal objects. Also found in Nigeria are the naturalistic terracotta and cast copper alloy commemorative heads and figures from Ife (figure 4), a culture which thrived from the twelfth to the early fifteenth century. With the extraordinary Igbo-Ukwu, Ife, and the so-called "Tsoede bronzes" (circa late thirteenth/fourteenth centuries), the ancient Nigerians achieved a high degree of excellence in metal casting which rivals other world cultures.

Bronze and terracotta figures *nos. 1-5* have emerged only recently in Mali near the ancient city of Djenné and date generally from 1000 A.D. to 1600 A.D. Nearby, the ancient Bamana peoples, until recently known as Bankoni after the name of the site where they were first discovered, produced terracottas *nos. 10-12* at approximately the same time. These early sculptures — along with the fired clay funerary heads of the Anyi *no. 46* and Akan *no. 47* in Côte

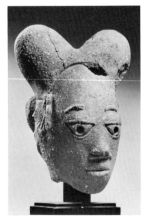

Figure 3

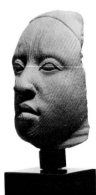

Figure 4

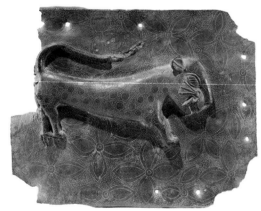

Figure 5

d'Ivoire and Ghana, the terracotta equestrian figures from the Gimbala region in Niger *no. 32,* and new finds which undoubtedly will continue to be made — are expanding the knowledge and understanding of this vast continent and its rich artistic heritage.

Power and Prestige

Throughout the ages, complex royal kingdoms have flourished in sub-Saharan Africa. Often incorporating a system of art patronage into their elaborate social structures, these

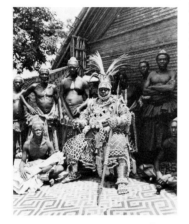

kingdoms have generated a wealth of magnificent objects associated with positions of power and prestige *nos. 48, 49, 61, 67, 96, 102, 112, 118, 124.* Perhaps most well-known to the western world is the royal art of the Kingdom of Benin in Nigeria. Dating from the fourteenth to the end of the nineteenth century, high relief cast copper alloy plaques (figure 5) depicting figures and animals decorated the palace compound walls of the king, or Oba. Intended only for usage within his royal court, intricately carved ivory bracelets and cast copper alloy miniature masks *no. 56* worn on a belt at the hip were created by the Oba's artisans. The great Ashanti Kingdom of Ghana also produced hoards of regal paraphenalia *nos. 48, 49,* mostly in cast, repoussé or leaf gold. The Kuba kings in Zaire enjoyed flamboyantly rich and decorative costumes and jewelry (figure 6) as well as elaborate and colorful masks *no. 119.* On the other hand the centuries-old series of individually carved portraits of each Kuba king (figure 7) gives a different exposure to the Kuba royal aesthetic.

Figure 6

Religion

To better appreciate and understand the meaning of a sculpture, a knowledge of the beliefs and customs of those people who made and used the object is helpful. Most West Africans have a religion, whether it is Christianity, Islam, or animism. While the first two were introduced to the peoples in the region by outsiders, animistic beliefs are indigenous and are of primary importance to the makeup of African art forms. Animism is essentially the belief that natural phenomena and objects such as rocks, trees, and sculptures are alive and possess a soul. For instance, the Bamana peoples of Mali are agriculturalists and incorporate their animistic beliefs in their farming practices. Their dance crests *nos. 13, 14* represent the antelope which symbolizes a mythical beast who taught the Bamana to cultivate the land. These crests are worn on top of the head by dancers whose movements imitate those of the antelope (figure 8). Rituals

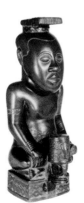

Figure 7

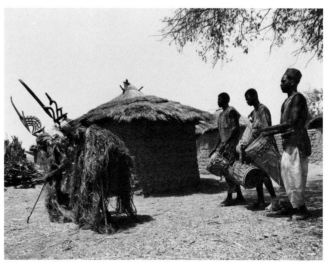

Figure 8

involving these crests are performed to ensure successful crop production and teach good farming skills and techniques.

The Artist

The status of the artist/sculptor varies from people to people, but, as a rule, this specialized knowledge assures him a position of some importance in the society. In many tribal groups the vocation is hereditary, handed down from father to son, and the young artist usually is required to serve an extended apprenticeship. This training is not concerned with creativity and originality as defined by twentieth-century aestheticians and critics from the western world. The content, media and function of art are givens to the Africans, established by cultural experience, education, and tradition. The artist has little control over subject matter or iconography; individual creativity is demonstrated by the refinement of execution and in variations of style.

These circumstances help to explain the lack of an equivalent stylistic evolution in the art of Africa as is found in western art. Demonstrating this phenomenon are the collections of African sculptures documented as having entered European museums from the seventeenth to nineteenth centuries and, for all intents and purposes, looking much like pieces of the same kind carved in recent times. A notable exception to this rule are the Benin sculptures which evince style changes through the centuries and can be dated accordingly.

While tribal styles and even sub-styles have been discernable, distinguishing the work of singular artists was difficult, if not impossible, until recently. However, following the pioneering studies of William Fagg among the Yoruba peoples in the 1950s and 1960s, art historians during the last two decades have begun the arduous task of identifying individual styles, although many names already are lost to history.

It is fortunate and rather unusual that six works here can be attributed to particular carvers. Represented are two of the few known mastercarvers of the Yoruba peoples of Nigeria. A six-foot high figure group *no. 75* is one of less than two dozen sculptures made by the great Olowe of Ise (d. 1938). Carved in the early years of this century, this architectural post embellished the veranda of a royal palace in Yorubaland. A bowl and a tray *nos. 70, 71* carved by Arowogun of Osi-Ilorin (circa 1880-1956) for use in Ifa divination ceremonies illustrate this recognized Yoruba artist's distinctive style. Sculptures by the Ashanti carver Nana Osei Bonsu (1900-1977) *no. 48*, the Shankadi Master of Sungu *no. 123* and the Eastern Luba Master of Mwanza *no. 124*, each demonstrate the individuality of these accomplished artists.

Materials

The material most commonly used for making sculptures is wood; but ivory, stone, vegetable fibre, bone and terracotta are employed as well as gold, brass, bronze, iron and tin. In the case of wood sculpture, the cylindrical nature of the tree prescribes the overall form of most figurative pieces.

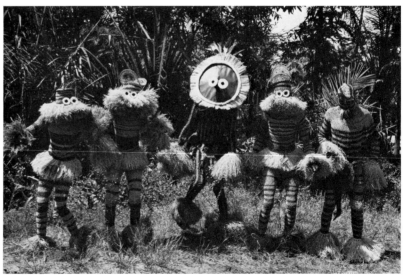

Figure 9

12

For easy handling, the wood usually is worked green or semi-dry. Initially rough hewn with an axe, the wood later is refined with other tools including adzes, knives and chisels. In many societies the tree is regarded with great respect and is considered a living element with its own spirit. The artist's function is to retain that life force in the sculpture with special rites often performed before the tree is felled.

The surface treatment of the work varies with the individual artist and from region to region. Some works are rubbed with rough surfaced leaves to obtain a smooth finish, others are incised, while polish made of a mixture of soot and fat is applied to still others as protection against weathering and termites. Pigment often is applied to sculpture, with red, white kaolin and ochre (earth muds) and black (charcoal) the most common. Dyes made from roots or bark are used for staining. The velvet, honey-colored patinas found on some wood sculpture have resulted from constant care, usage and repeated handling by the Africans over many years.

Often through the accumulative additions of other materials, the embellished sculpture takes on an entirely different character and aesthetic. Such is the case with the beaded cape and cap of the Yoruba royal twin figure *no. 67*; the raffia ruff and elaborate woven and painted fibre headdress of the Yaka mask *no. 113*; the string, cloth and feathers added to the diminutive Yaka fetish figure *no. 114*; the calabash, monkey fur and shells on the Eastern Luba wood divination figures *nos. 125, 126*; the animal skin, brass tacks, rawhide, fur and figurative charm of the Songye figure *no. 128*; the human hair, horn, iron and feathers of the Kran mask *no. 41*; the cowrie shells, glass beads, and leather attached to the Yoruba kneeling *eshu* figure *no. 68*; the aluminum, brass and cloth of the Malinke mask *no. 20*; and the skin-covered sculptures from the Cross River area *nos. 88, 89, 90, 91, 92, 93*.

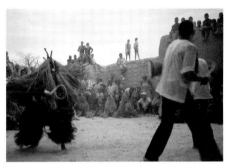

Figure 10

Perhaps the most dramatic transformations are seen in the wood Dogon figure with raised arms *no. 7*, the Bamana mask with *boli* headdress *no. 16* and the Kuba royal helmet mask *no. 119*.

Masks

African tribal sculpture is identified generally as either masks, figures or utilitarian objects. Used in dances and ceremonies associated with farming and hunting activities or funerals and initiation rites (figure 9), masks were never intended to be displayed as static objects in an institutional environment such as an art museum. When viewing them in this way, it is important to remember that movement is of utmost importance in conveying the meaning of the mask. Usually worn with a full costume, masks are part of a dynamic, dramatic spectacle in which dance, music, and the chanting of songs are integral elements (figure 10). These rituals are used to enact certain myths, to teach moral lessons, to mete out justice and punishment, and even to entertain. In essence, masks are part of a tradition used to reinforce the social structure and beliefs of the people.

For the African, the mask is powerful only when it is in use and when the wearer is anonymous. A costume made either of grass, raffia or fabric is attached to the mask to disguise the wearer's identity. During ceremonies a spirit is believed to enter the mask and the wearer *becomes* the agent who communicates the will of this spirit to the people. Masked dances are related to an association of people called a secret society. The masks made by the Yaure peoples

of the Côte d'Ivoire *nos. 42, 43* are used as part of a group activity and are not for individual use. Because of damage or general deterioration from usage, a mask sometimes requires replacement, and an artist is commissioned to carve a similar one. The animistic spirit then is transferred from the old to the new and the original mask is discarded as a useless piece of wood. It no longer possesses special aesthetic or magic powers for the African. Resulting from this lack of interest in preservation, untold quantities of carved wood sculptures have been lost because of abandonment and purposeful destruction as well as insect intrusion and decomposition from rot.

Masks are worn over the face, on top of the head or as a helmet. Often the mask combines human features with those of animals or birds, or combinations of animal features. Frequently, this hybrid representation is executed boldly in designs exhibiting an expressive simplification and distortion of natural form. Since the spiritual meaning of the mask does not require the artist to imitate nature, he is free to emphasize or suppress certain elements for effect. The face masks from the Poro secret society of the Dan peoples in Liberia *nos. 38, 39* embodies supernatural powers and knowledge of magic formulae which are used in masquerades directed against lawbreakers, sorcerers, and malevolent spirit forces such as witches. In essence, this mask is an object which is used as an agent of social control and can act as a substitute for a court judge or policeman.

Initiation

Initiation is important in African societies and can either involve the entry of an individual into a secret society, or it can mark the end of childhood and the acceptance of the adolescent as an adult. In the latter, boys (and sometimes girls) are separated for a period from the village. During this time, they are instructed about cult secrets, the history of their ancestors, ritual songs and dances, and their rights and responsibilities as adults in the tribe. Masks from the Pende and Yaka peoples in Zaire *nos. 113, 115* are utilized for such special instructional ceremonies and rites of passage. Initiation usually involves physical transformations as well, such as circumcision, tattooing and scarification.

Women seldom play an active part in masked ceremonies and are usually excluded from secret societies. One notable exception, however, is the Sande secret society of the Mende women in Sierra Leone whose helmet masks *no. 36* embody a protective spirit which assists in training girls in the skills and responsibilities of being good wives.

Figures

Figures, like masks, are linked closely with rituals and ceremonies, but unlike masks, are static objects seldom seen in public. Customarily they are used by private cults and secret societies *nos. 26, 50, 80* rather than by the general populace. They contain divine power which is used for a variety of purposes such as healing, protection from evil and for promoting fertility or prosperity.

In general terms, most African figurative sculpture has proportions unlike those found in nature or western art. The six-inch ivory figure from the Lega peoples in Zaire *no. 110* is a case in point. Usually the head is enlarged, the torso elongated, and the arms and legs shortened and slightly bent. The Lobi figure from Burkina Faso *no. 23* clearly demonstrates the common characteristics of frontality, rigid symmetry and no discernable facial expression.

Fetishes are believed to hold magic powers given by the *ngoga* or tribal priest who

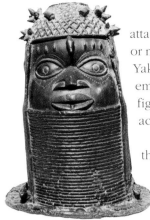

Figure 11

attaches magic bundles to the navel or the head of the figure. The power is used for benign or malign purposes of healing or making ill. Without the magic, the figure is powerless. The Yaka fetish *no. 114*, five and one-half inches high, most likely contains magical ingredients embedded under the wrapped body and base. On the other hand the Obamba/Mindumu figure *no. 108* and the Lumbo reliquary head *no. 109* originally were surmounted on and acted as guardians for attached tied bundles containing relics and other sacred objects.

Commemorative figures celebrate either kings, chiefs or mythical characters. Those that honor kings often depict an important event or specific attribute for which his reign is recognized rather than illustrating a personalized portrait (figure 7). Likewise, the Ife and Benin heads (figure 11) are not of the individual, but of qualities associated with royalty such as dignity, prestige and aloofness.

Ancestor figures *no. 106* play a vital role in African tribal culture. The ancestors are viewed as givers of life and bearers of tribal tradition. When a man dies, his spirit can wander around threatening those still alive until it finds a resting place in an ancestral sculpture. The figures holding bowls *nos. 122, 123* from the Shankadi in Zaire represent deceased members of the tribe and were used as offering containers of sacred earth by healers as a link between the living and the dead. A reminder of this intimate relationship is expressed in the elaborate Fon peoples altar *no. 55* with the deceased seated in a chair and surrounded by symbolic objects of social status. In general it is believed that the ancestor protects individuals and communities and assists them safely through dangerous periods.

Utilitarian Objects

Many common utilitarian objects for everyday usage such as storage jars *no. 18*, smoking pipes *no. 103*, drinking cups *no. 118* and oil lamps *no. 28* and furniture such as chairs *no. 129* and stools *nos. 22, 99, 102* often are given special aesthetic attention in African societies. They are crafted with much thought given to their appearance and design. The small Yoruba divination cup *no. 72* reflects the African's concern for beauty. Special objects indigenous to African culture such as brass counterweights for weighing gold *no. 53*, weaving pulleys *no. 45* and headrests become miniature sculptures in themselves. A wooden comb *no. 51* exemplifies how an implement common to everyday usage is elevated beyond a mere tool. Africans have a penchant for wearing jewelry; necklaces, neck rings, earrings, fingerrings, hairpins, pendants, amulets, anklets, armlets, bracelets, and other articles of personal adornment *nos. 31, 61, 96* have a richness of invention and beauty in form. Woven cloths, mainly for use as apparel, are embellished with embroidery, paint, tie-dye, applique and stencil to create a rich assortment of patterning and other visual effects. Also functioning as art objects are musical instruments such as horns, rattles, thumb pianos, whistles, flutes and harps decorated with figurative and geometric motifs.

Architecture

For Africans, architecture is yet another outlet for creative expression. The walls of buildings often are decorated imaginatively with stylized designs or mural scenes in low relief sculpture and/or paint to incorporate art with architecture. Other parts of habitable structures such as posts, columns, lintels, doors, and windows *nos. 9, 75, 76, 77* are similarly transformed into artworks in themselves.

African Art and the Western World

African art is a new field of art history. Only in the past twenty-five years have there been trained African art historians. The first attempts to analyze the cultural artifacts of sub-Saharan Africa were carried out mainly by European anthropologists, ethnographers, and others in the 1930s and 1940s. Notable among them for their pioneering studies are Eckart von Sydow, Carl Kjersmeier, Marcel Griaule, George Harley, Frans Olbrechts and Leon Underwood. But earlier, European artists such as Pablo Picasso, Georges Braque, André Derain and Henri Matisse in Paris and the Die Brücke group of German Expressionist artists in Dresden were among the first, at the beginning of the twentieth century, to recognize African art for its creative and aesthetic value. They discovered the objects, collected by the nineteenth-century explorers and traders, in ethnographic museums and curio shops. This led to the adoption of African aesthetics and formal conventions in their own cubist and expressionist art. A comparison of the female heads in Picasso's 1907 landmark oil *Les Demoiselles d'Avignon* (figure 12), which launched the new cubist style, with a Yaure face mask *no. 43* shows how Picasso drew inspiration from the African art forms. Other European artists who collected ethnographic art for themselves were Maurice de Vlaminck, Jacob Epstein, André Breton, and Max Ernst. The influence of African sculpture on contemporary European and American art continues today with many artists, both black and white, drawing inspiration, often in quite subtle ways. African art has been incorporated into the repertory of forms and styles available to and utilized by contemporary artists.

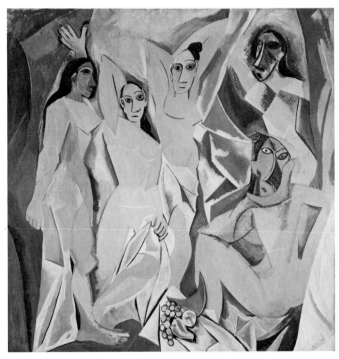

Figure 12

In conjunction with the introduction of works by many of these avant-garde European artists to America, Alfred Steiglitz presented at his "291" gallery in New York the first exhibition of African art in the United States in November 1914. This initial display of eighteen works was followed in 1935 by the daring undertaking of James Johnson Sweeney in assembling six-hundred tribal sculptures for the exhibition *African Negro Art* at The Museum of Modern Art in New York. Demonstrating the affinity of the tribal and the modern, the catalogue cover for the 1984 exhibition *"Primitivism" in 20th Century Art* at the same museum contrasted a mixed media Tusyan mask from Burkina Faso with a 1935 bronze sculpture *Bird-Head* by Max Ernst.

In addition to the *"Primitivism"* exhibition at the Modern, this decade has seen a flurry of activity bringing African art forms into the mainstream of art history. Incorporating the holdings of the Museum of Primitive Art, the Metropolitan Museum of Art in New York opened in January 1982 its first permanent space devoted to African art, the Michael C. Rockefeller Wing. Three years later The Center for African Art, also in New York, initially opened with the

exhibition *African Masterpieces from the Musée de l'Homme*. Perhaps the most significant landmark event occurred in September 1987 when, in Washington D.C, the United States became the first country outside Africa to inaugurate a national museum devoted exclusively to African art.

For hundreds of years the western world thought of Africa as "the Dark Continent" without a history or cultural development. Today, with a multitude of public and private collections of African art and an increasing number of important exhibitions worldwide, this fallacy is being dispelled. In contrast to earlier notions about them, the peoples of sub-Saharan Africa do indeed have a long and rich history which is endowed with a strong artistic heritage both extraordinarily creative and multi-faceted.

Figures

1 Map of Africa indicating the four basic geographic zones of art-producing peoples.

2 Sherbro-Portuguese style, Sherbro Island, Sierra Leone, *Saltcellar*, circa 16th century, ivory, The Trustees of the National Museum of Scotland.

3 Nok Culture, Nigeria, *Head*, 500 B.C.-200 A.D., terracotta, Count Baudouin de Grunne Collection, Brussels, Belgium. Photograph: P. Asselberghs, Brussels

4 Ife Culture, Nigeria, *Fragment of a Head*, terracotta, The Brooklyn Museum, Lent by the Guennol Collection, L54.5.

5 Benin Kingdom, Nigeria, *Leopard Plaque*, circa 16th-17th centuries, cast copper alloy, New Orleans Museum of Art, Gift of Mr. and Mrs. Frederick Stafford, 80.194. Photograph: Trahan-Brocato.

6 Bushongo or Kuba Kingdom, Zaire, Mushenge *Nyim* Mbop Mabiinc maMbaky (Bope Mabinshe) ruled 1939-d. 1969. Photograph: Eliot Elisofon, Eliot Elisofon Archives, National Museum of African Art.

7 Bushongo or Kuba Kingdom, Zaire, *Royal Portrait of Bom Bush*, wood, The Brooklyn Museum. Gift of Mr. and Mrs. Robert E. Blum, Mr. and Mrs. Alistair B. Martin, and Mr. and Mrs. Donald M. Oenslager; and Mrs. Florence E. Blum Fund, 61.33.

8 Bamana Peoples, Bamako Area, Mali, *chi wara* antelope dancers. Photograph: Eliot Elisofon, Eliot Elisofon Archives, National Museum of African Art.

9 Pende Peoples, near Gungu, Zaire, *Minganji* masks. Photograph: Eliot Elisofon, Eliot Elisofon Archives, National Museum of African Art.

10 Bobo funeral dance, village of Pala, Burkina Faso. Photograph: William A. Fagaly, March 1987.

11 Benin Kingdom, Nigeria, *Head of an Oba*, late 18th century, cast copper alloy, iron, New Orleans Museum of Art, Anonymous Gift, 53.12.

12 Pablo Picasso, *Les Demoiselles d'Avignon*, 1907, oil on canvas, The Museum of Modern Art, New York, acquired through the Lillie P. Bliss Bequest.

Western Sudan

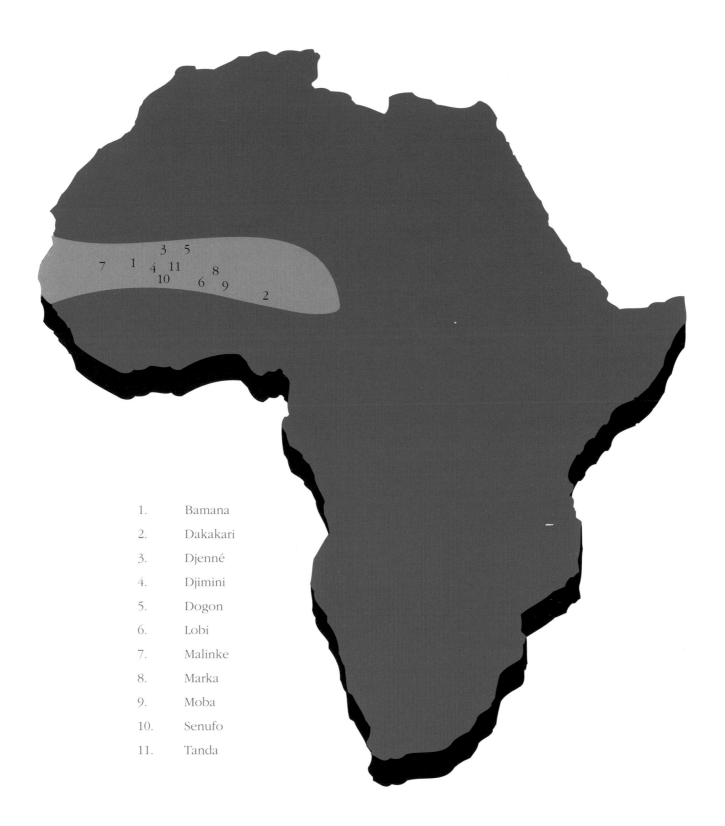

1.	Bamana

2.	Dakakari

3.	Djenné

4.	Djimini

5.	Dogon

6.	Lobi

7.	Malinke

8.	Marka

9.	Moba

10.	Senufo

11.	Tanda

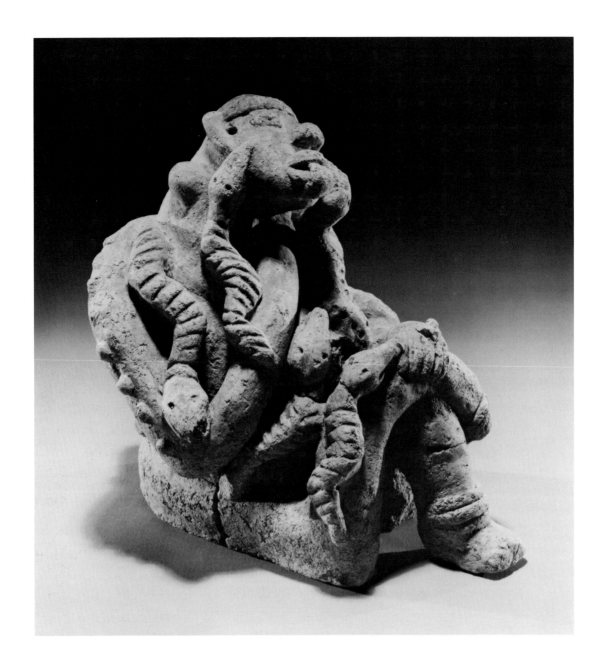

1
Djenné Culture, Mali
Seated Woman Covered with Snakes, circa 1100-1500 A.D.*
terracotta, pigment
10 1/2 x 10 1/2 x 8 1/2 (26.6 x 26.6 x 21.6)
Alice Mayer-Katz, Dr. Walda Katz-Fishman,
and Judge and Mrs. Robert A. Katz Collection

*Thermoluminescence test results date this object as being "between 490
and 900 years of age," Daybreak Nuclear and Medical Systems, Inc.,
Guilford, Connecticut, January 11, 1985.

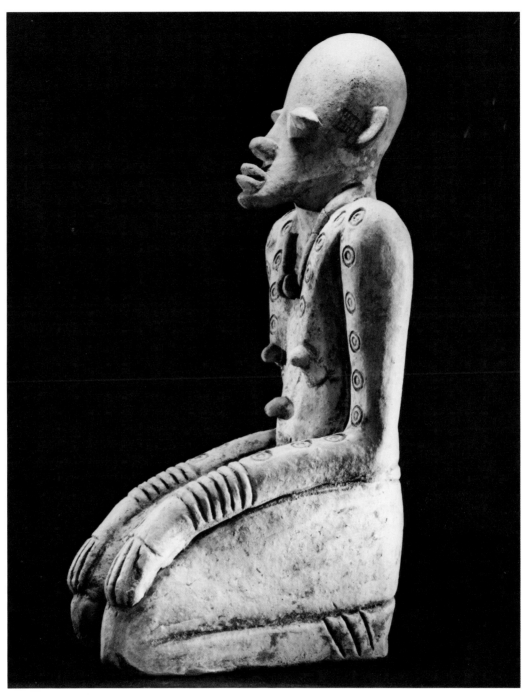

2
Djenné Culture, Mali
Kneeling Woman, circa 1400-1600 A.D.*
terracotta, pigment
15 x 6 1/4 x 1 3/4 (38.1 x 15.8 x 4.5)
Mr. and Mrs. J. Thomas Lewis Collection

*Thermoluminescence test results date this object as being made "between 375 and 610 years ago," Daybreak Nuclear and Medical Systems, Inc., Guilford, Connecticut, April 11, 1984.

3
Djenné Culture, Mali
Snake, circa 1230 -1590 A.D.*
terracotta
1 3/4 x 11 7/8 x 3 3/4 (4.5 x 30.1 x 9.5)
E. John Bullard Collection

* Thermoluminescence test results estimate
this object was last fired "580 +/- 180 years
ago." Daybreak Nuclear and Medical Systems, Inc.,
Guilford, Connecticut, January 31, 1989.

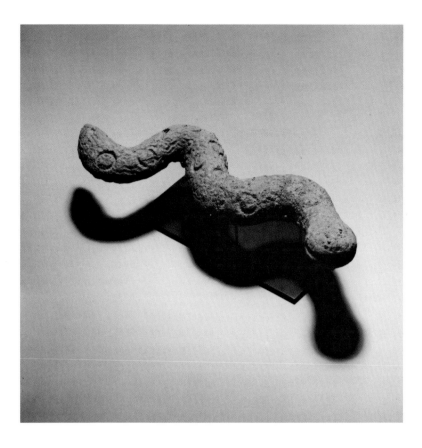

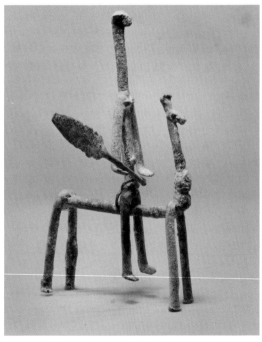

4
Djenné Culture, Mali
Equestrian Figure, circa 12th to 17th
centuries A.D.
bronze
6 1/4 x 4 x 4 (15.8 x 10.2 x 10.2)
Anonymous Collection

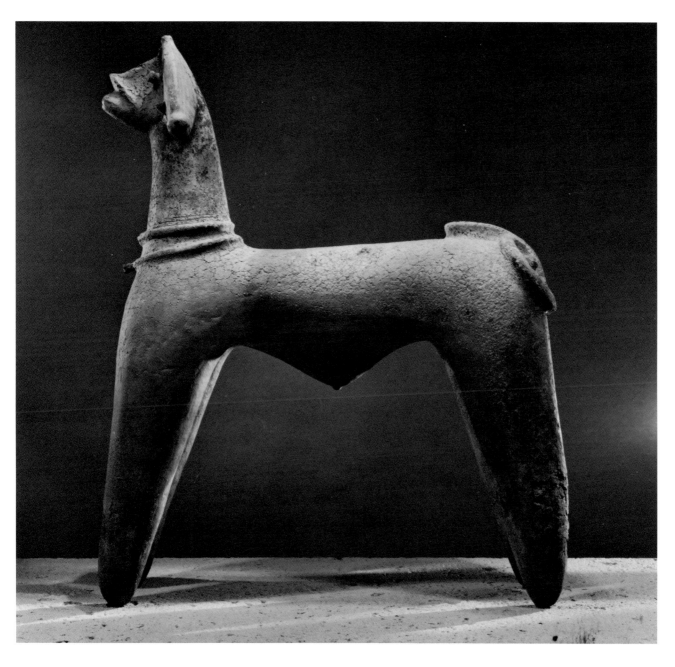

5
Djenné Culture, Mali
Standing Figure of a Ewe, circa 1300-1650 A.D.*
terracotta
30 1/2 x 10 x 25 3/4 (77.5 x 25.4 x 65.5)
Kathe and Bill Watson Collection
cover illustration

*Thermoluminescence test results date this object as being made "between 350 and 670 years ago,"
Daybreak Nuclear and Medical Systems, Inc., Guilford, Connecticut, May 13, 1988.

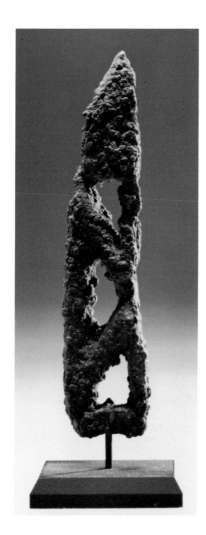

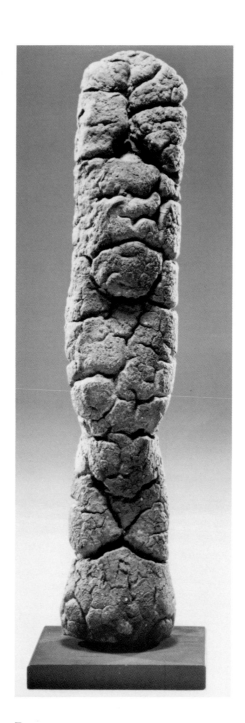

6
Dogon Peoples, Mali
Seated Figure with Hands on Chin
wood, encrustation
3 3/8 x 3/8 x 5/8 (8.6 x .8 x 1.6)
Anonymous Collection

7
Dogon Peoples, Tellem Style, Mali
Figure with Raised Arms
wood, sacrificial material
6 3/4 x 1 1/4 x 1 1/4 (17.2 x 3.2 x 3.2)
Kent and Charles Davis Collection

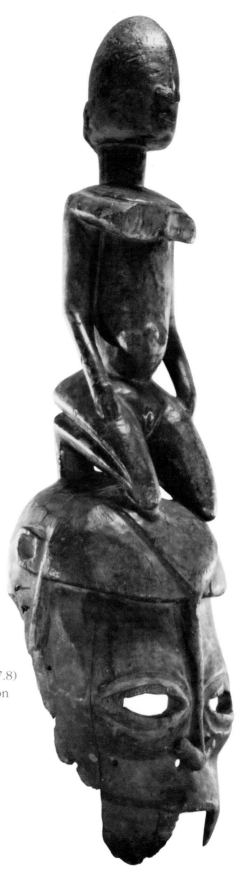

8
Dogon Peoples, Mali
Mask with Kneeling Figure
wood
23 1/4 x 6 x 7 (59.1 x 15.2 x 17.8)
Kent and Charles Davis Collection

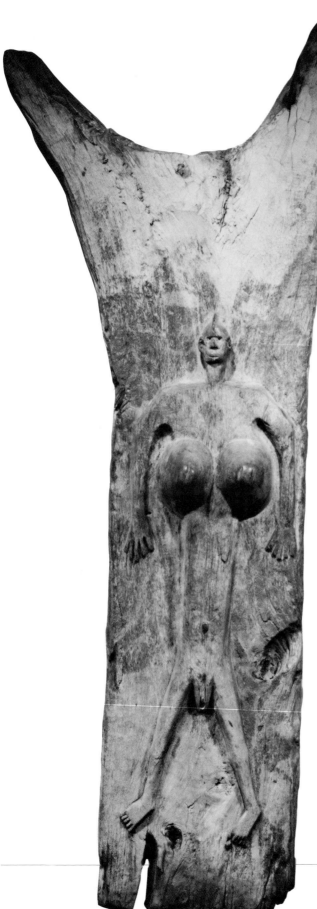

9
Dogon Peoples, Mali
Toguna Post with Woman (*togu kubo*)
wood, pigment
64 x 26 x 7 1/2 (162.6 x 66 x 19)
Mr. and Mrs. J. Thomas Lewis Collection

10
Bamana Peoples, Mali
Kneeling Woman, circa 1400-1600 A.D*.
terracotta, pigment
12 1/8 x 3 3/8 x 6 1/8 (30.7 x 8.6 x 15.5)
Justine and Richard McCarthy Collection

*Thermoluminescence test results date this object as
being made "between 400 and 610 years ago,"
Daybreak Nuclear and Medical Systems, Inc.,
Guilford, Connecticut, March 14, 1981.

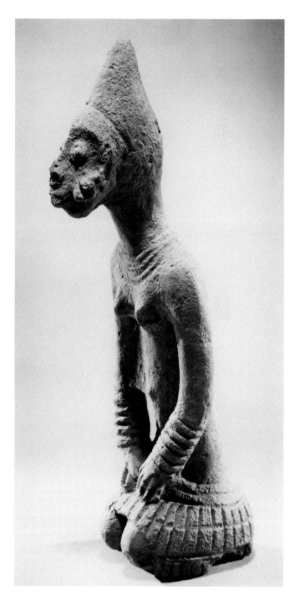

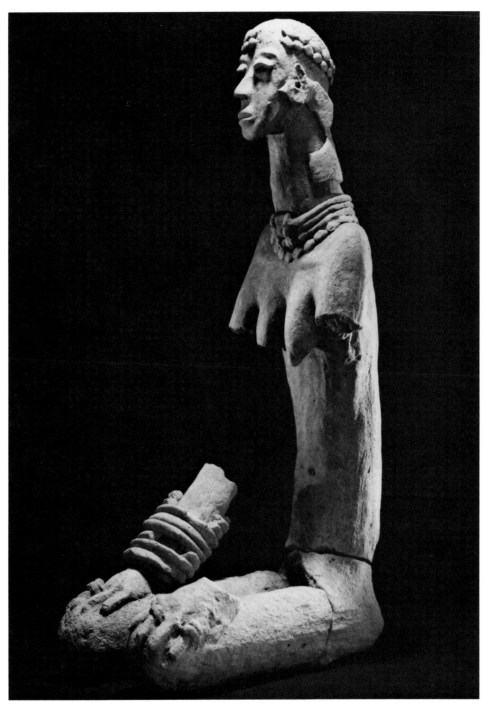

11
Bamana Peoples, Mali
Seated Woman, circa 1200 A.D.*
terracotta
26 3/4 x 8 x 14 (67.9 x 20.3 x 35.6)
Anonymous Collection

*Thermoluminescence test results date this object as being made "between 530 and 1000 years ago, 790 most probable." Daybreak Nuclear and Medical Systems, Inc., Guilford, Connecticut, February 11, 1987.

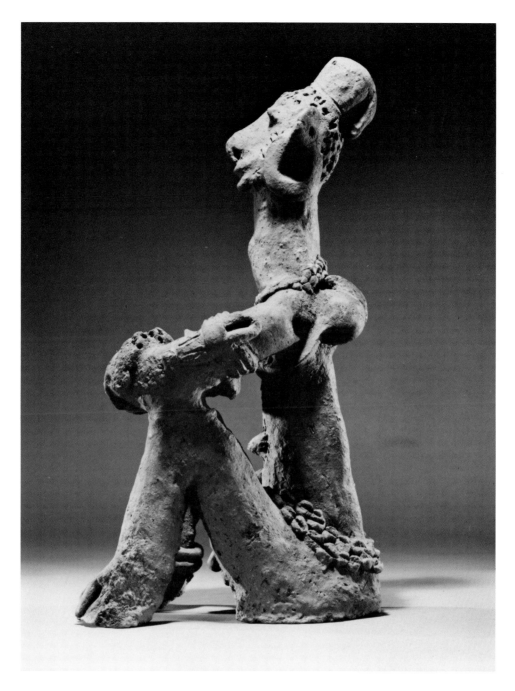

12
Bamana Peoples, Mali
Seated Man, circa 1450 A.D.*
terracotta
19 3/4 x 9 x 10 7/8 (50.2 x 22.9 x 27.7)
Alice Mayer-Katz, Dr. Walda Katz-Fishman, and Judge and Mrs. Robert A.
Katz Collection

*Thermoluminescence test results date this object as being made "between 360 and 660 years ago, 520 most probable," Daybreak Nuclear and Medical Systems, Inc., Guilford, Connecticut, August 22, 1984.

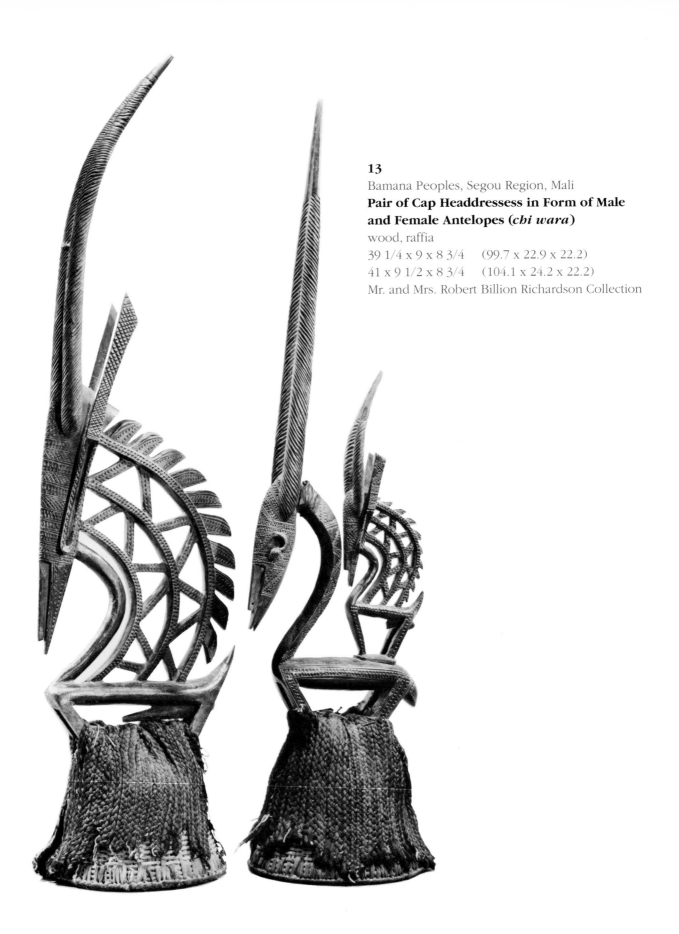

13
Bamana Peoples, Segou Region, Mali
**Pair of Cap Headdressess in Form of Male
and Female Antelopes (*chi wara*)**
wood, raffia
39 1/4 x 9 x 8 3/4 (99.7 x 22.9 x 22.2)
41 x 9 1/2 x 8 3/4 (104.1 x 24.2 x 22.2)
Mr. and Mrs. Robert Billion Richardson Collection

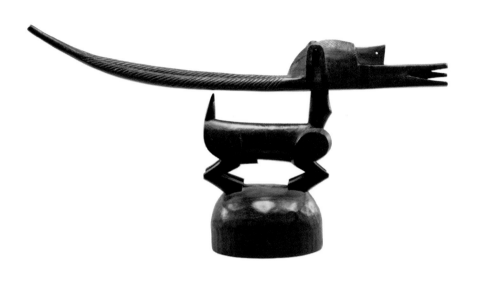

14
Bamana Peoples, Segou Region, Mali
Cap Headdress in Form of Antelope (*chi wara*)
wood
14 3/4 x 31 x 7 5/8 (37.5 x 78.7 x 19.3)
Vernon Palmer Collection

15
Jo Society, Bamana Peoples, Mali
Staff Figure
wood, rope, fibre, bone, iron, earth, sacrificial materials
25 1/2 x 6 1/2 x 6 (64.8 x 16.5 x 15.2)
Anonymous Collection

16
Bamana Peoples, Mali
Face Mask with *Boli* Headdress
wood, pigment, yarn, feathers, cloth,
encrustation, parrot head
41 x 8 1/4 x 14 (104.2 x 21 x 35.6)
Kathe and Bill Watson Collection

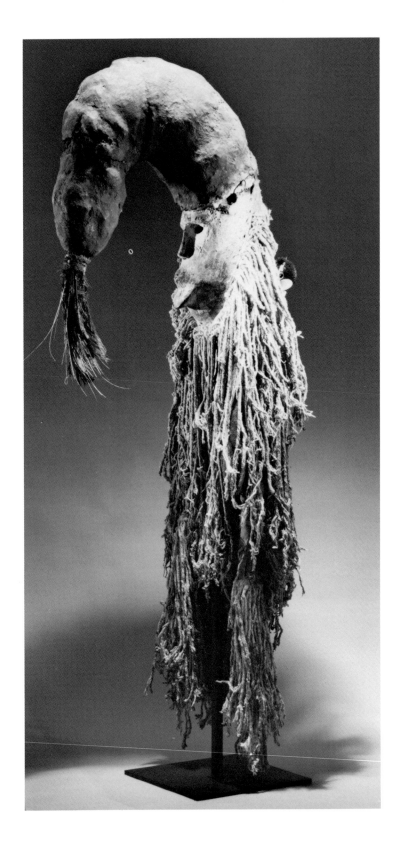

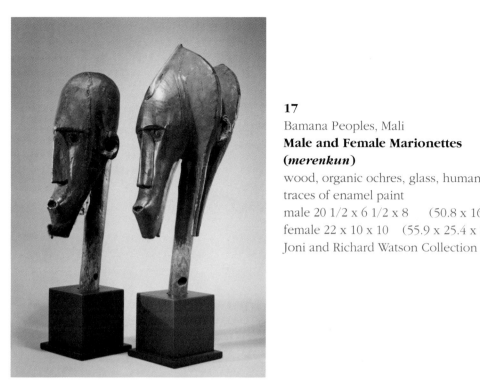

17
Bamana Peoples, Mali
**Male and Female Marionettes
(*merenkun*)**
wood, organic ochres, glass, human hair,
traces of enamel paint
male 20 1/2 x 6 1/2 x 8 (50.8 x 16.5 x 20.3)
female 22 x 10 x 10 (55.9 x 25.4 x 25.4)
Joni and Richard Watson Collection

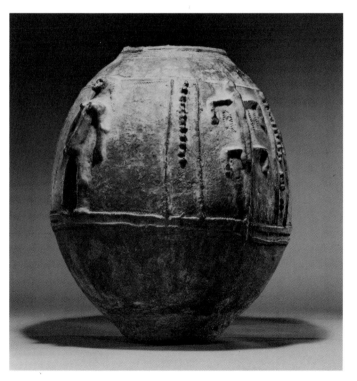

18
Bamana Peoples, Mali
Storage Jar
terracotta
19 3/4 x 17 x 15 3/4 (50.2 x 43.2 x 40)
Robert Gordy Collection (bequeathed to
the New Orleans Museum of Art in
1987)

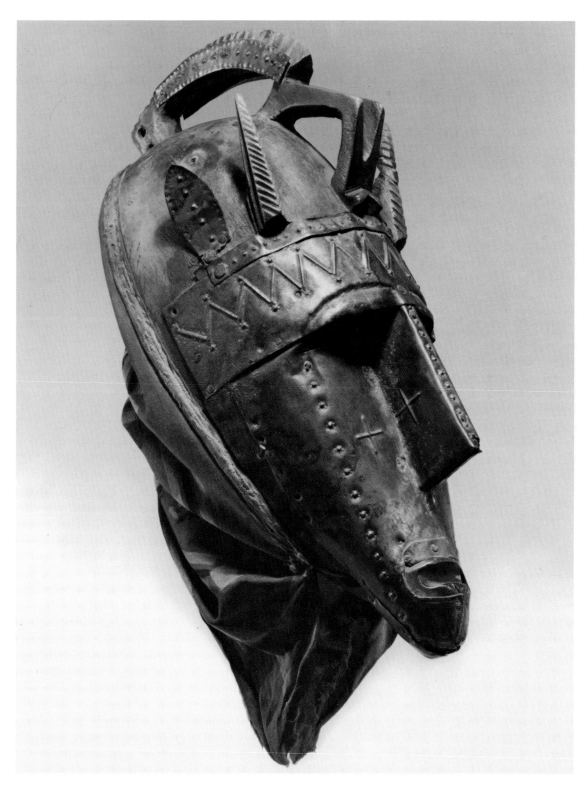

19
Marka Peoples, Mali
Face Mask
wood, brass, printed cloth
31 x 6 x 5 3/4 (78.7 x 15.2 x 14.6)
Minnie and James Coleman, Jr. Collection

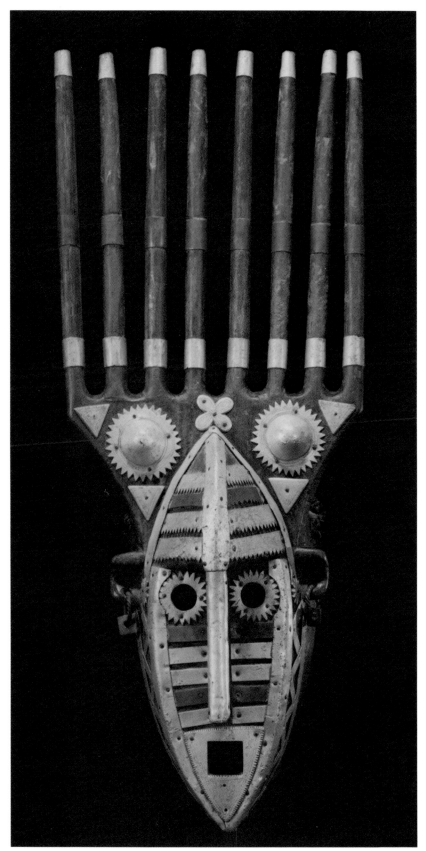

20
Malinke Peoples, Mali
Face Mask
wood, aluminum, brass, cloth
29 1/2 x 8 1/2 x 6 1/2 (74.9 x 21.6 x 16.5)
Mr. and Mrs. J. Thomas Lewis Collection

21
Lobi Peoples, Burkina Faso/Ghana
Anthropomorphic Head
wood
11 3/4 x 4 1/4 x 5 3/4 (29.8 x 10.8 x 14.6)
Françoise Billion Richardson Collection

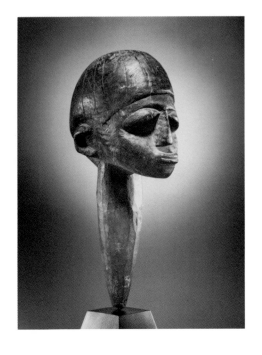

22
Lobi Peoples, Burkina Faso/Ghana
Stool with Human Head
wood
9 1/4 x 6 3/4 x 21 (23.5 x 17.2 x 53.3)
Joseph Powell Collection

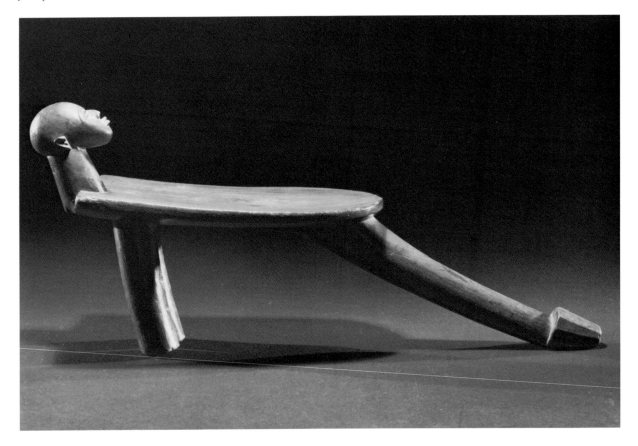

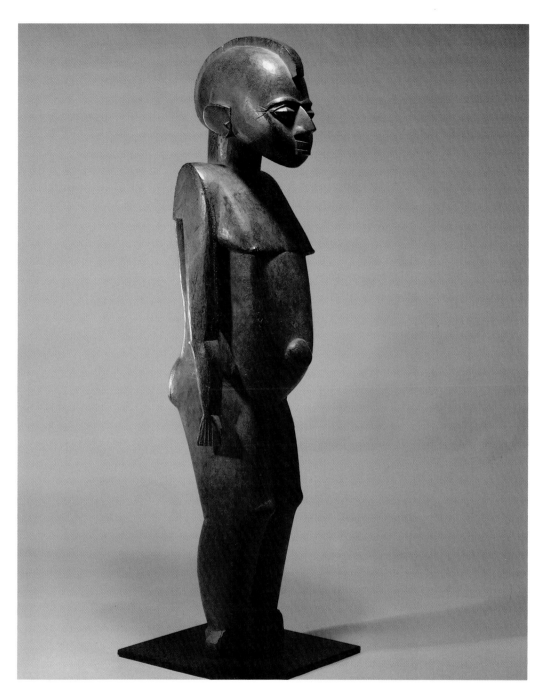

23
Lobi Peoples, Burkina Faso/Ghana
Standing Man
wood
34 1/2 x 7 1/2 x 8 1/2 (87.6 x 19 x 21.6)
Joni and Richard Watson Collection

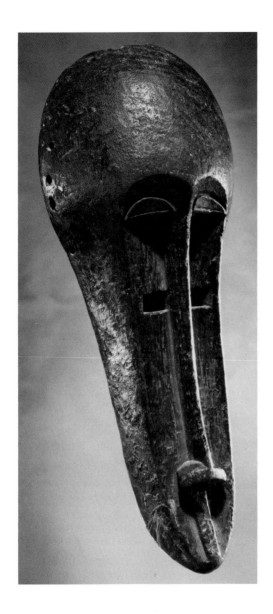

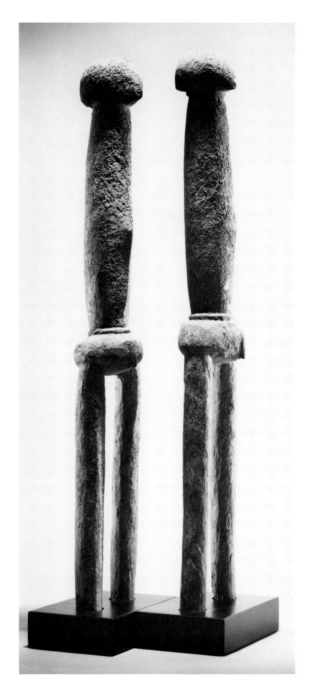

24
Djimini Peoples, Côte d'Ivoire
Face Mask
wood, animal hair
17 1/2 x 6 3/4 x 7 (44.5 x 17.2 x 17.8)
Françoise Billion Richardson Collection

25
Moba Peoples, North Ghana/North Togo
Pair of Male Figures
wood, encrustation
27 3/4 x 4 7/8 x 3 1/2 (70.5 x 12.4 x 8.9)
27 1/2 x 4 3/8 x 3 3/8 (69.8 x 11.1 x 8.6)
Ida and Hugh Kohlmeyer Collection

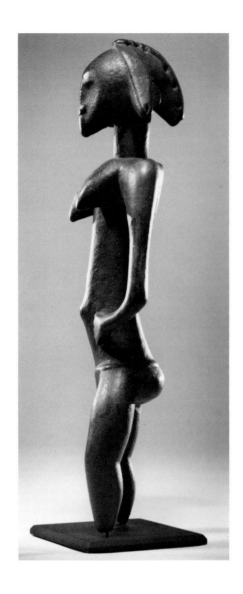

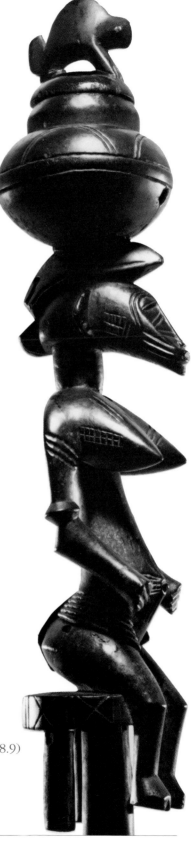

26
Senufo Peoples, Côte d'Ivoire
Divination Figure
wood
13 x 3 1/2 x 2 3/4 (33 x 8.9 x 7)
Kent and Charles Davis Collection

27
Senufo Peoples, Côte d'Ivoire
Cultivator Staff
wood
55 x 3 3/4 x 3 1/2 (139.7 x 9.5 x 8.9)
Anonymous Collection
detail

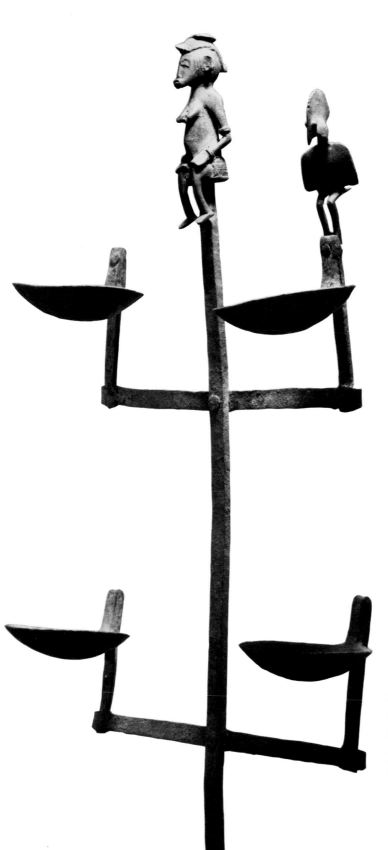

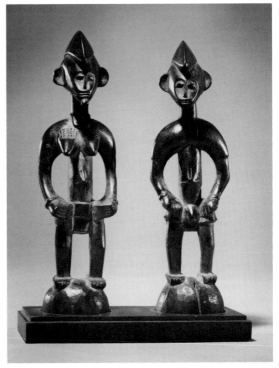

29
Senufo Peoples, Côte d'Ivoire
Man and Woman
wood
male 9 x 2 1/2 x 2 1/4 (22.9 x 6.4 x 5.7)
female 9 x 2 3/4 x 2 1/4 (22.9 x 7 x 5.7)
Ida and Hugh Kohlmeyer Collection

28
Senufo Peoples, Côte d'Ivoire
Oil Lamp
iron
35 3/8 x 13 1/2 x 4 1/8 (89.8 x 34.3 x 10.5)
Michael Myers and Dr. H. Russell Albright Collection

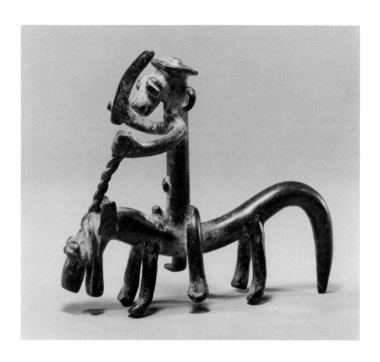

30
Senufo Peoples, Côte d'Ivoire
Equestrian Figure
bronze
4 1/4 x 1 3/4 x 4 3/4 (10.8 x 4.5 x 12.1)
Kent and Charles Davis Collection

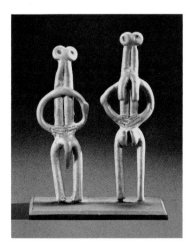

31
Tanda Peoples, Côte d'Ivoire
Pair of Amulets of a Man and Woman
brass
male 2 1/4 x 5/8 x 3/8 (5.7 x 1.6 x .8)
female 2 1/2 x 5/8 x 1/4 (6.4 x 1.6 x .6)
Mr. and Mrs. J. Thomas Lewis Collection

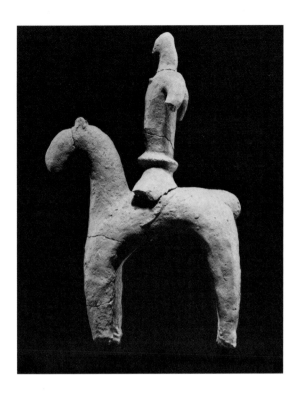

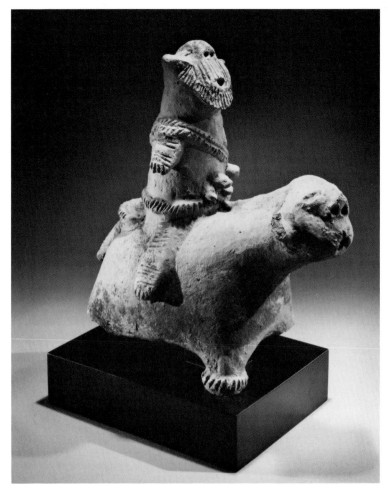

32
Undetermined Peoples, Gimbala Region, Niger
Funerary Equestrian Figure
circa 1000-1500 A.D.*
terracotta
9 1/2 x 2 1/2 x 6 1/8 (24.2 x 6.4 x 15.5)
Polly and Edward Renwick Collection

*Thermoluminescence test dates this object as being made
"between 480 and 940 years ago," Daybreak Nuclear and
Medical Systems, Inc., Guilford, Connecticut,
September 26, 1986.

33
Dakakari Peoples, Nigeria
Funerary Equestrian Figure
terracotta
16 x 8 x 15 (40.6 x 20.3 x 38.1)
Carol and Dr. George Harell Collection

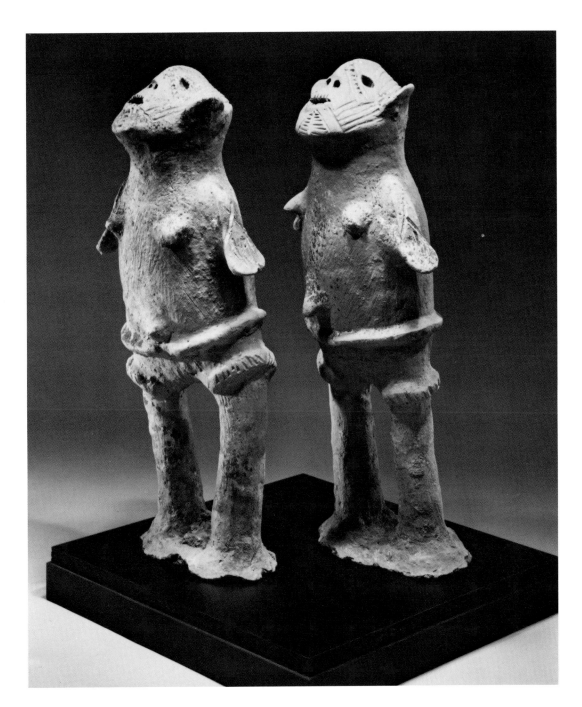

34
Dakakari Peoples, Nigeria
Pair of Female Funerary Figures
terracotta, traces of pigment
19 x 8 x 5 (48.2 x 20.3 x 12.7)
18 1/2 x 6 1/4 x 3 1/2 (47 x 15.8 x 8.9)
Kathe and Bill Watson Collection

Guinea Coast

1. Agni
2. Akan
3. Ashanti
4. Baule
5. Bete
6. Bini
7. Dan
8. Fon
9. Kulango
10. Mende
11. Owo
12. Yaure
13. Yoruba

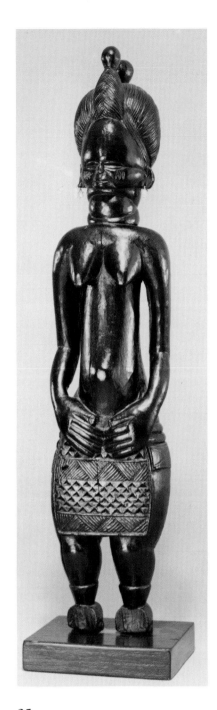

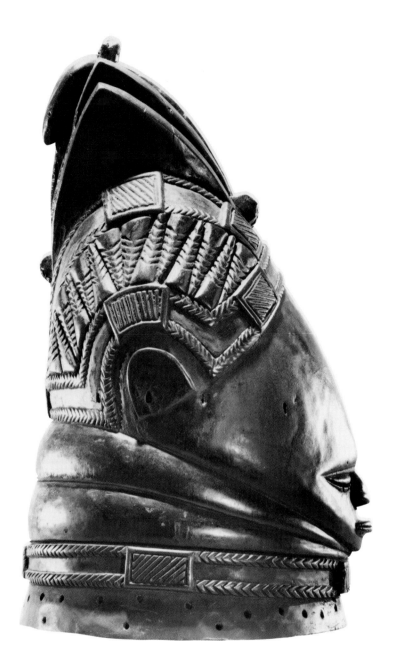

35
Mende, possibly Sherbro Peoples, Sierra
Leone/Liberia
Medicine Figure (*minsereh*)
wood, glass beads
26 x 3 3/4 x 5 1/2 (66 x 9.5 x 14)
Jane and Henry Lowentritt Collection

36
Sande Association, Mende, possibly Gola
Peoples, Sierra Leone/Liberia
Helmet Mask
wood
16 1/2 x 7 3/4 x 10 (41.9 x 19.7 x 25.4)
Dr. and Mrs. Raoul Bezou Collection

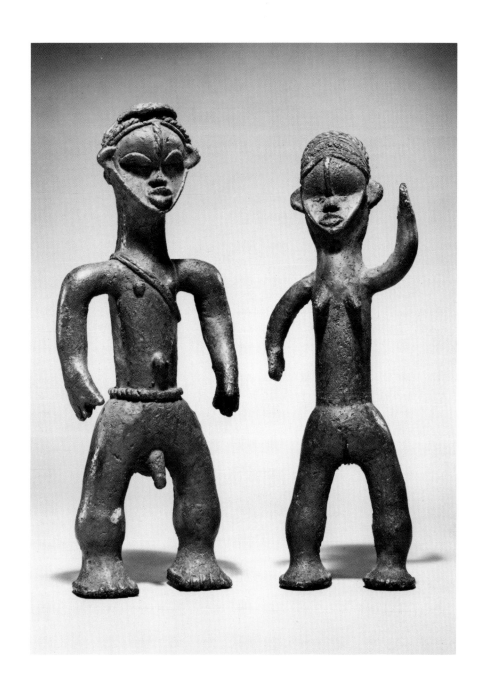

37
Dan or We (Kran) Peoples, Liberia
Standing Man and Woman Figures
brass
male 7 3/4 x 3 x 1 3/4 (19.7 x 7.6 x 4.5)
female 7 1/2 x 2 3/4 x 1 1/2 (19 x 7 x 3.8)
Anonymous Collection

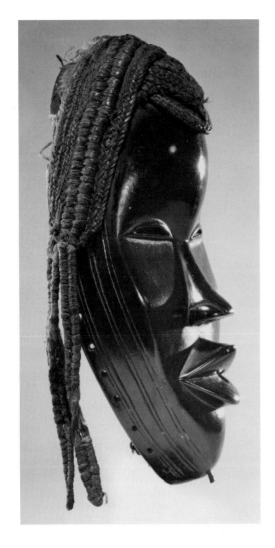

38
Poro Society, Dan Peoples, Liberia
Face Mask
wood, raffia, iron
9 1/2 x 5 1/2 x 3 (24.2 x 14 x 7.6)
Anonymous Collection

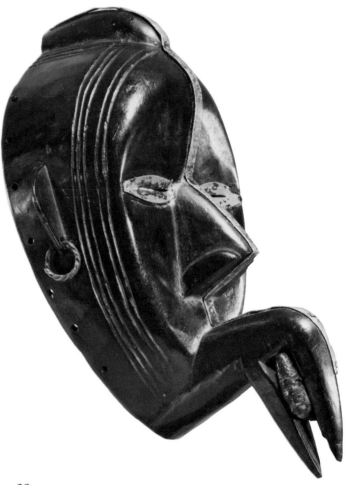

39
Poro Society, Dan Peoples, Liberia
Face Mask
wood, aluminum, brass, leather
12 1/4 x 7 x 5 1/2 (31.1 x 17.8 x 14)
Barbara and Wayne Amedee Collection

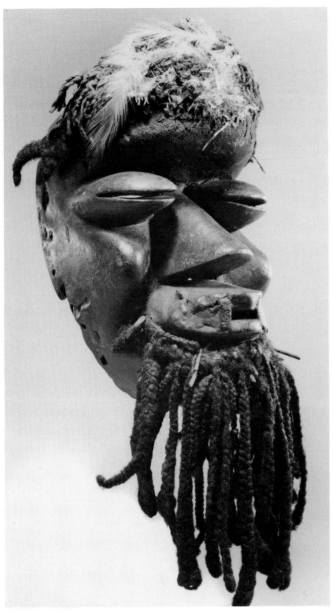

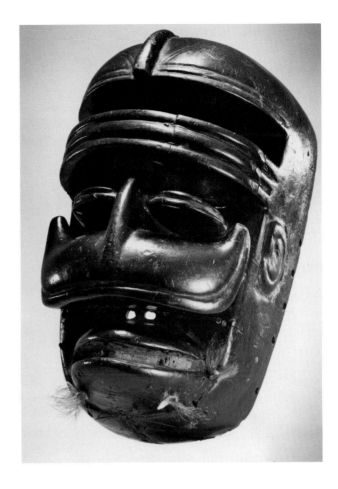

41
Bete Peoples, Liberia
Face Mask
wood, feathers, nails, camwood powder
10 1/2 x 6 1/8 x 5 1/4 (26.6 x 15.5 x 13.3)
Dorothy Mahan Collection

40
We (Kran) Peoples, Liberia
Face Mask
wood, human hair, animal horn, iron, feathers
16 3/4 x 7 1/2 x 6 (42.5 x 19 x 15.2)
Kent and Charles Davis Collection

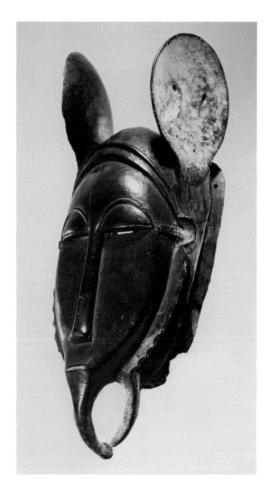

42
Yaure Peoples, Côte d'Ivoire
Face Mask in Form of an Elephant
wood, pigment
13 x 5 x 6 (33 x 12.7 x 15.2)
Nancy Stern Collection

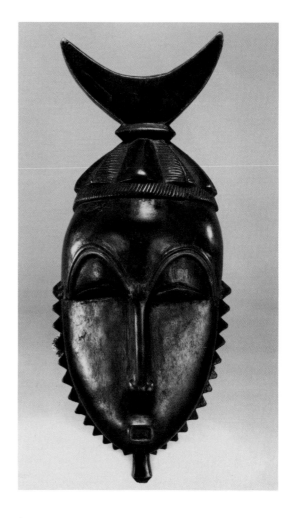

43
Yaure Peoples, Côte d'Ivoire
Face Mask
wood, string
15 x 5 1/2 x 4 (38.1 x 13.9 x 10.1)
Nancy Stern Collection

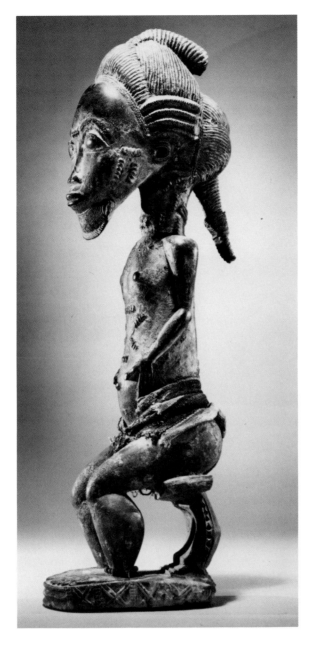

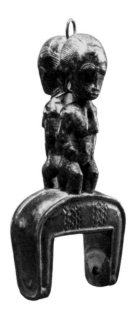

44
Baule Peoples, Côte d'Ivoire
Nature Spirit (*asie usu*)
wood, cloth, metal, kaolin
17 1/2 x 3 1/2 x 5 1/2 (44.5 x 8.9 x 14)
Kent and Charles Davis Collection

45
Baule Peoples, Côte d'Ivoire
**Heddle Pulley with Figures of
Two Women**
wood
7 1/4 x 3 1/4 x 2 (18.5 x 8.2 x 5.1)
Ida and Hugh Kohlmeyer Collection

46
Agni Peoples, Côte d'Ivoire/Ghana
Memorial Funerary Head (*mma*)
terracotta
10 7/8 x 5 x 6 1/2 (27.6 x 12.7 x 16.5)
Ida and Hugh Kohlmeyer Collection

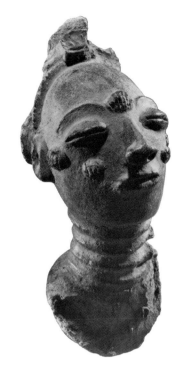

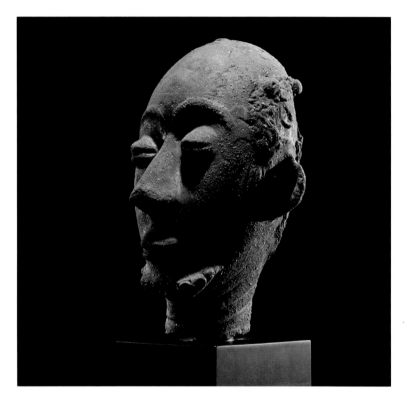

47
Akan Peoples, Hemang-Twifo Region, Ghana
Memorial Funerary Head, circa 1830 A.D.*
terracotta
10 3/8 x 6 x 6 1/4 (26.3 x 15.2 x 15.8)
Ida and Hugh Kohlmeyer Collection

48
Ashanti Peoples, Ghana
Nana Osei Bonsu, carver (1900-1977)
Linguist Staff Finial (*okyeame poma*)
circa 1925.
wood, gold leaf
16 x 6 x 6 (40.6 x 15.2 x 15.2)
Anonymous Collection
detail

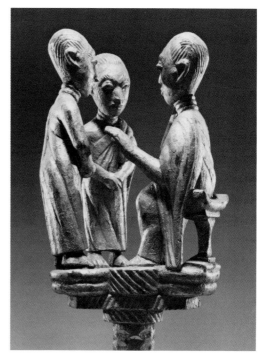

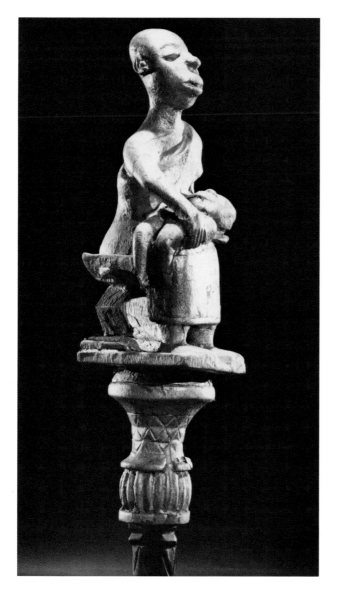

49
Ashanti Peoples, Ghana
**Linguist Staff with Seated Maternity Figure
(*okyeame poma*)**
wood, gold leaf, pigment
63 1/2 x 4 1/4 x 3 3/4 (161.3 x 10.8 x 9.5)
Dr. and Mrs. Raoul Bezou Collection
detail

50
Ashanti Peoples, Ghana
Fertility Doll (*akuaba*)
wood, glass beads
14 3/8 x 6 5/8 x 2 1/2 (36.5 x 16.8 x 6.4)
Gene Willett Collection

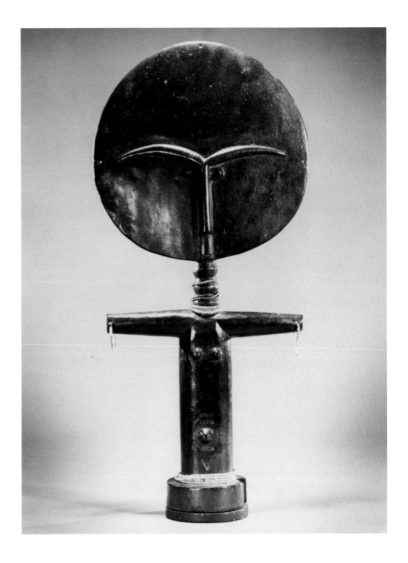

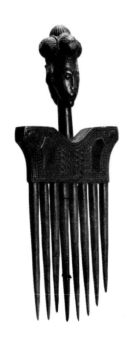

51
Western Ashanti or Eastern Bron Peoples, Ghana
Comb with Janus Heads
wood
7 1/2 x 3 1/4 x 1 1/8 (19 x 8.3 x 2.9)
Nancy Stern Collection

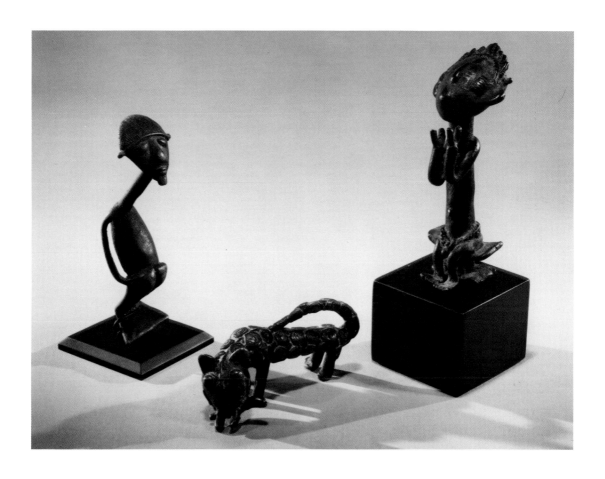

54
Kulango Peoples, Ghana
Standing Man
bronze
4 x 1 1/2 x 1 5/8 (10.2 x 3.8 x 4.1)
Anonymous Collection

53
Ashanti Peoples, Ghana
Goldweight in Form of Leopard
brass
1 1/2 x 1 1/2 x 3 1/4 (3.8 x 3.8 x 8.2)
Princess Yashodhara and Dr. Siddharth Bhansali Collection

52
Ashanti Peoples, Ghana
Seated Figure
bronze
4 x 1 3/4 x 2 (10.2 x 4.5 x 5.1)
Kent and Charles Davis Collection

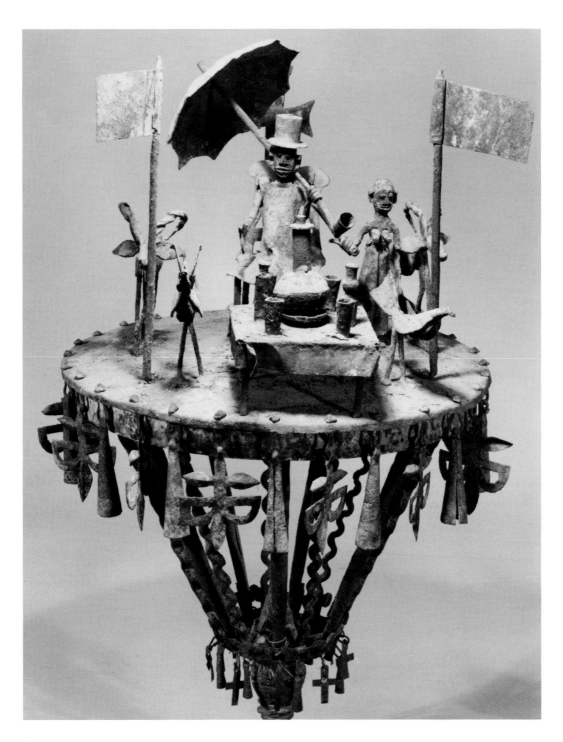

55
Fon Peoples, Republic of Benin
***Asen* Altar**
wrought iron, raffia, wood, fetish bundle
56 x 16 1/2 diameter (142.2 x 41.9 diameter)
Françoise Billion Richardson Collection
(promised gift to the New Orleans Museum of Art)
detail

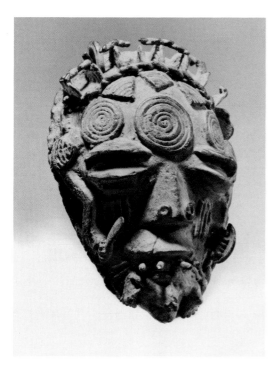

56
Bini Peoples, Benin Kingdom, Nigeria
Hip Mask
cast copper alloy
5 1/8 x 3 1/2 x 1 1/2 (13 x 8.9 x 3.8)
Michael Myers and Dr. H. Russell
Albright Collection

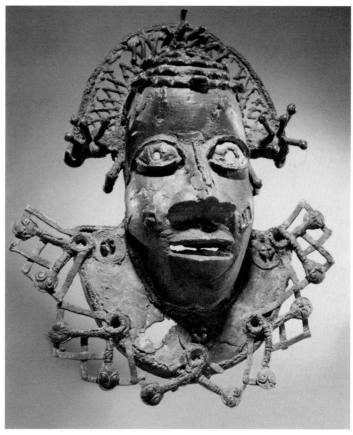

57
Kingdom of Owo, Nigeria
Pendant Mask
bronze
8 3/4 x 7 1/4 x 2 3/4 (22.2 x 18.5 x 7)
Ida and Hugh Kohlmeyer Collection

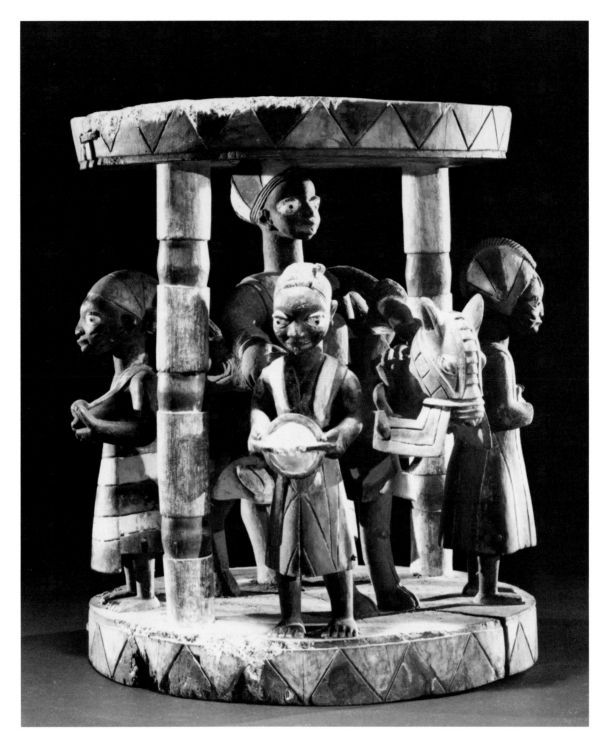

58
Yoruba Peoples, Ketu Region, Nigeria/Republic of Benin border
Stool
wood, organic ochres
16 x 13 1/2 diameter (40.6 x 34.3 diameter)
Ida and Hugh Kohlmeyer Collection

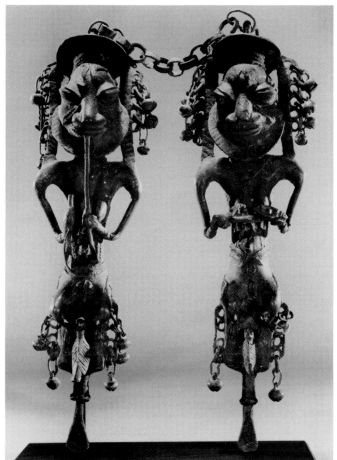

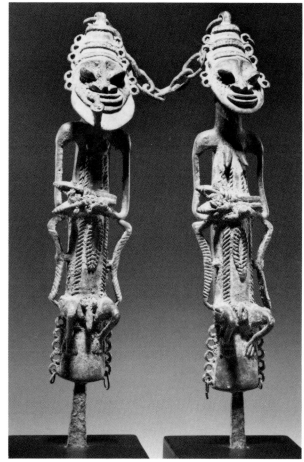

59
Ogboni Society, Yoruba Peoples, Nigeria
Pair of Staffs (*edan oshugbo*)
bronze
13 1/2 x 3 3/4 x 2 1/2 (34.3 x 9.5 x 6.4)
12 3/4 x 3 3/4 x 2 1/2 (32.4 x 9.5 x 6.4)
Nancy Stern Collection

60
Ogboni Society, Yoruba Peoples, Nigeria
Pair of Staffs (*edan oshugbo*)
bronze
12 3/8 x 1 7/8 x 2 1/4 (31.4 x 4.7 x 5.7)
12 1/2 x 2 x 1 3/4 (31.7 x 5.1 x 4.5)
Polly and Edward Renwick Collection

61
Ogboni Society, Yoruba Peoples, Nigeria
Chief's Armlet
bronze
5 x 4 1/4 x 4 (12.7 x 10.8 x 10.2)
Françoise Billion Richardson Collection

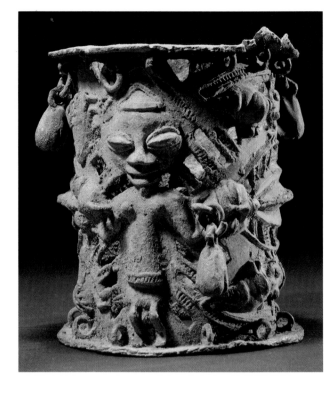

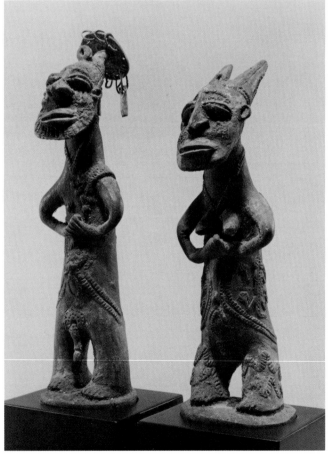

62
Ogboni Society, Yoruba Peoples, Nigeria
Standing Pair of Figures (*edan oshugbo*)
bronze
10 7/8 x 3 1/2 x 4 1/4 (27.7 x 8.9 x 10.8)
12 x 3 1/4 x 4 (30.5 x 8.3 x 10.1)
Renna and John Godchaux Collection

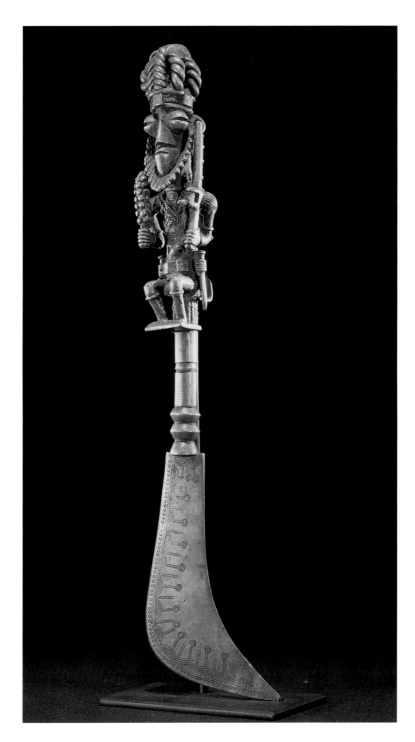

63
Yoruba Peoples, Nigeria
Staff with Ogun Figure (*iwano ogun*)
brass
18 1/4 x 4 1/8 x 1 3/4 (36.4 x 10.5 x 4.5)
Mr. and Mrs. J. Thomas Lewis Collection

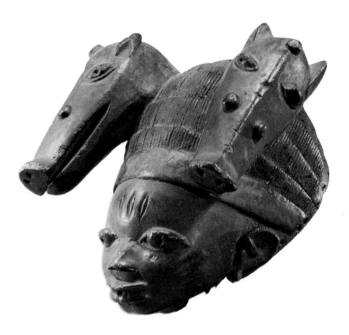

64
Gelede Society, Yoruba Peoples, Ketu Region, Nigeria
Headdress with Wart Hogs (*imado*)
wood, pigment
12 1/4 x 10 x 9 (31.1 x 25.4 x 22.9)
Michael Myers and Dr. H. Russell Albright Collection

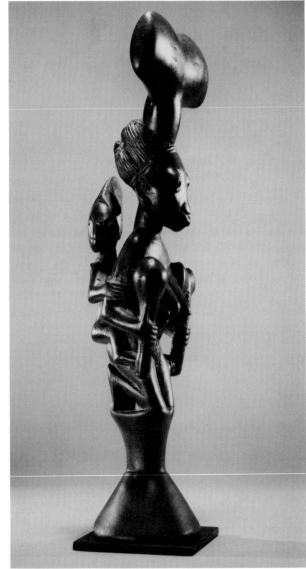

65
Yoruba Peoples, Nigeria
**Staff for Shango with
Maternity Figure (*oshe shango*)**
wood
17 3/4 x 4 1/4 x 3 1/4 (45.1 x 10.8 x 8.2)
Dr. and Mrs. Raoul Bezou Collection

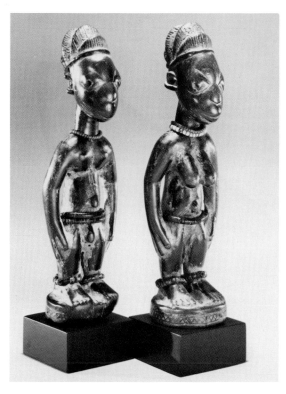

66
Yoruba Peoples, Nigeria
Twin Figures (*ere ibeji*)
wood, glass beads
10 1/4 x 3 x 2 3/4 (26 x 7.6 x 7)
10 1/4 x 3 1/8 x 2 1/2 (26 x 8 x 6.4)
Kathe and Bill Watson Collection

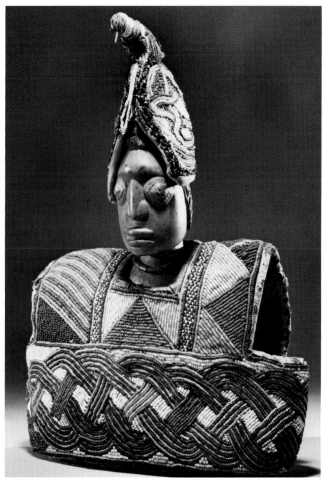

67
Yoruba Peoples, Nigeria
Royal Twin Figure (*ere ibeji*)
wood, camwood powder, glass beads, cloth
14 1/4 x 10 1/2 x 4 3/4 (36.2 x 26.6 x 12.1)
Mrs. P. Roussel Norman Collection

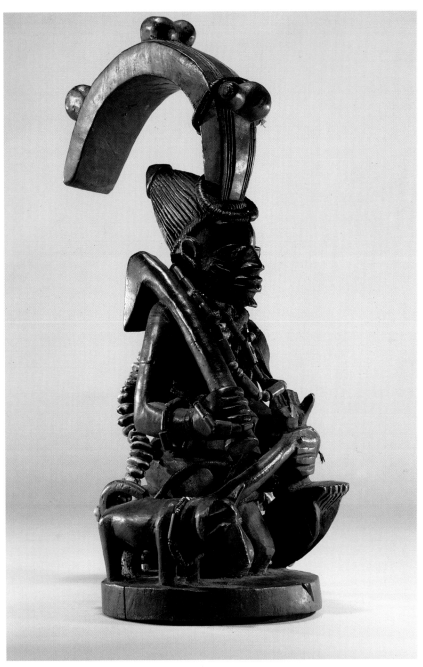

68
Yoruba Peoples, Nigeria
Kneeling Male *Eshu* Figure (*ogo elegba*)
wood, cowrie shells, glass beads, leather
16 1/8 x 7 1/2 x 7 3/4 (41 x 19 x 19.7)
Mayer-Katz Foundation Collection

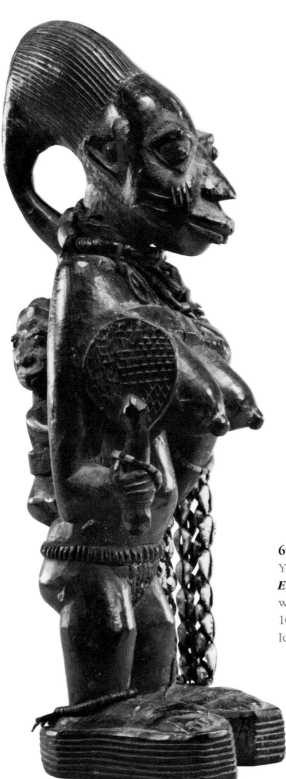

69
Yoruba Peoples, Igbomnia Region, Nigeria
***Eshu* Maternity Figure**
wood, cowrie shells, beads, coins, cotton
16 x 5 1/2 x 4 3/4 (40.6 x 14 x 12.1)
Ida and Hugh Kohlmeyer Collection

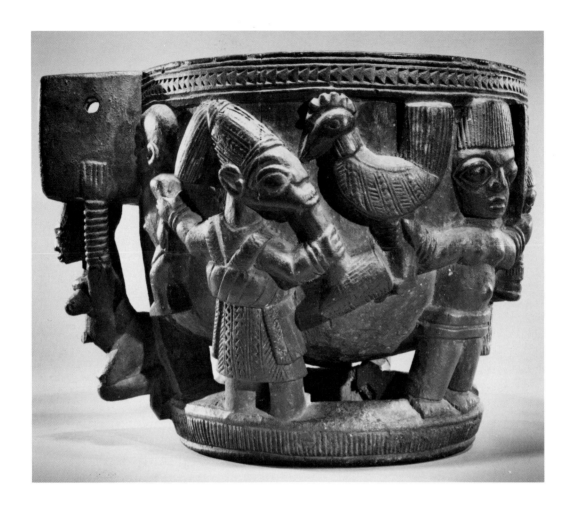

70
Yoruba Peoples, Ekiti Region, Nigeria
Arowogun of Osi-Ilorin, carver (circa 1880-1956)
Divination Bowl (*opon igede* or *igbaje* Ifa)
wood
10 1/4 x 14 x 11 diameter (26 x 35.6 x 28 diameter)
Nancy Stern Collection

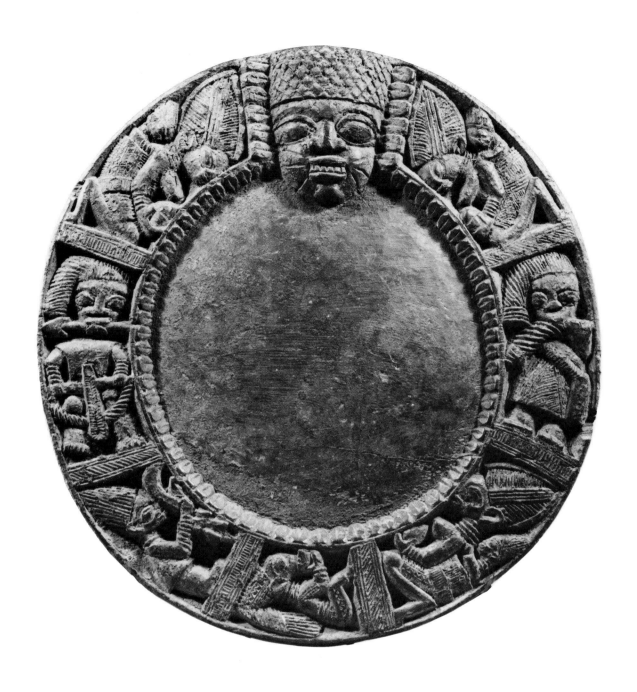

71
Yoruba Peoples, Ekiti Region, Nigeria
Arowogun of Osi-Ilorin, carver (circa 1880-1956)
Divination Tray (*opon* Ifa)
wood
1 3/4 x 18 x 18 1/4 (4.5 x 45.7 x 46.4)
Michael Myers and Dr. H. Russell Albright Collection

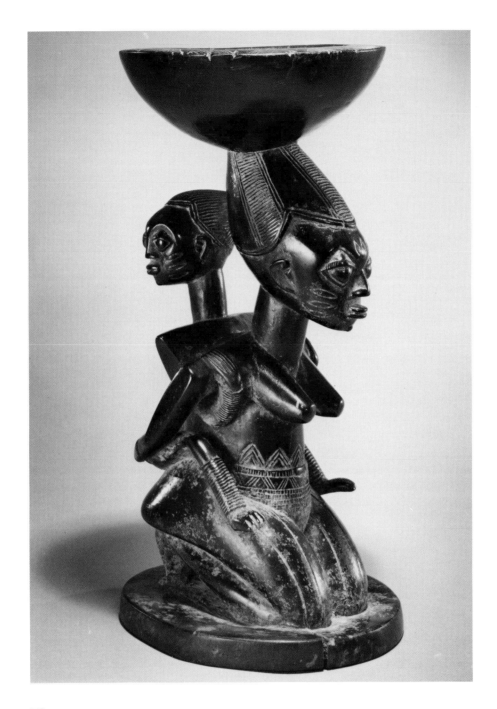

72
Yoruba Peoples, Nigeria
Caryatid Divination Cup with Maternity Figure (*agere* Ifa)
wood
12 1/2 x 5 1/2 x 5 3/4 (31.7 x 14 x 14.6)

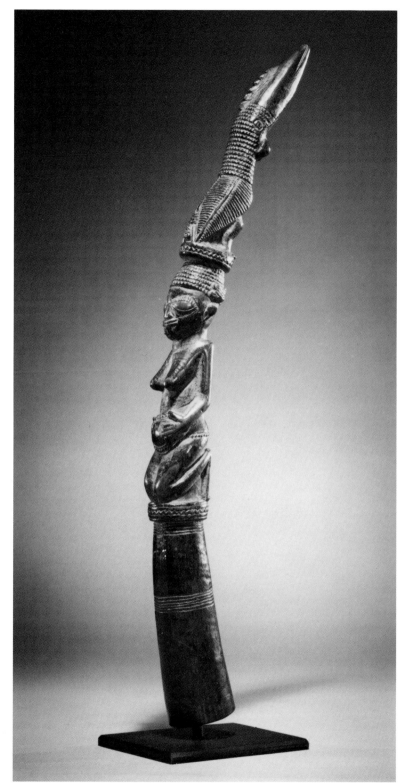

73
Yoruba Peoples, Owo Region, Nigeria
Divination Tapper
(***iro*** or ***iroke*** **Ifa**)
ivory
17 x 1 1/2 x 1 3/4 (43.2 x 3.8 x 4.5)
Françoise Billion Richardson Collection

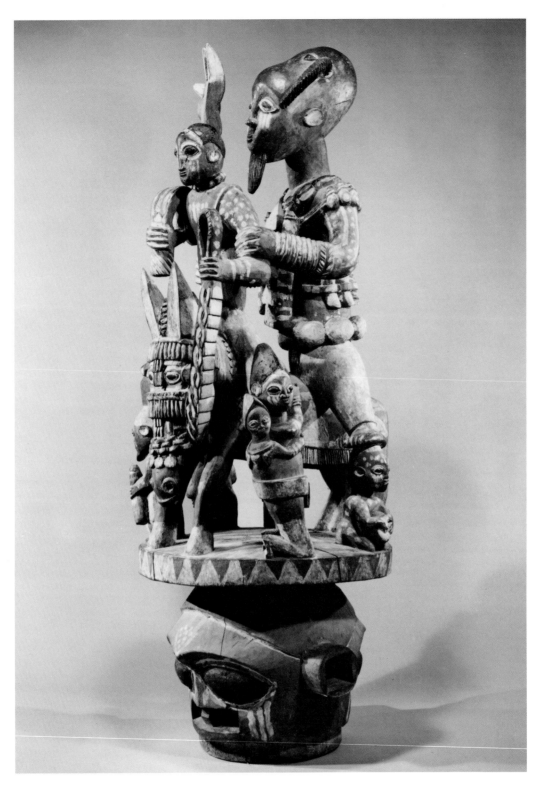

74
Yoruba Peoples, Ekiti Region, Nigeria
***Epa* Mask and Headdress of *Ao* (*jagun jagun*)**
wood, pigment
53 x 21 x 19 1/2 (134.6 x 53.3 x 49.5)
Joni and Richard Watson Collection

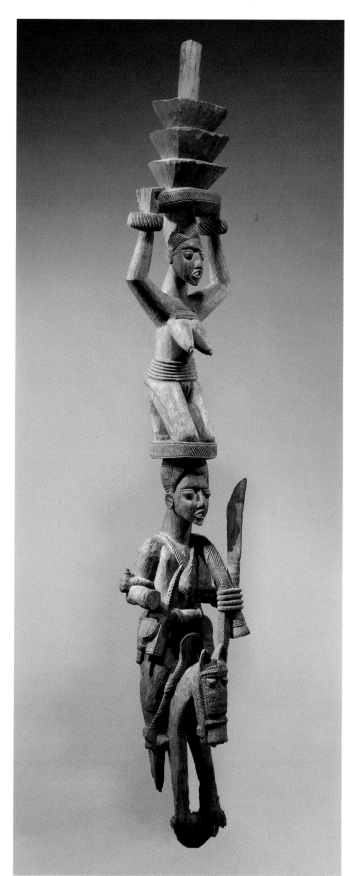

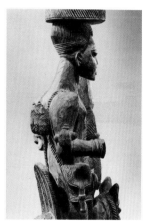

75
Yoruba Peoples, Ekiti Region, Nigeria
Olowe of Ise, carver (died 1938)
Veranda Post (*opo*)
wood, pigment
71 1/2 x 11 1/2 x 10 1/2 (179.1 x 29.2 x 26.6)
Katherine and Richard Buckman Collection
frontispiece detail

76
Yoruba Peoples, Ekiti Region, Nigeria
Palace Door with Figures in Four Registers (*ilekun afin*)
wood
56 3/4 x 23 5/8 x 1 3/4 (144.2 x 60 x 4.5)
Alice Mayer-Katz, Dr. Walda
Katz-Fishman, and Judge and Mrs. Robert
A. Katz Collection

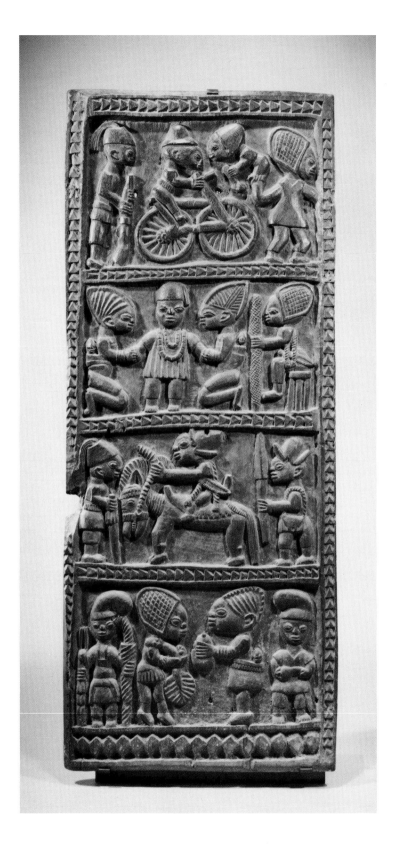

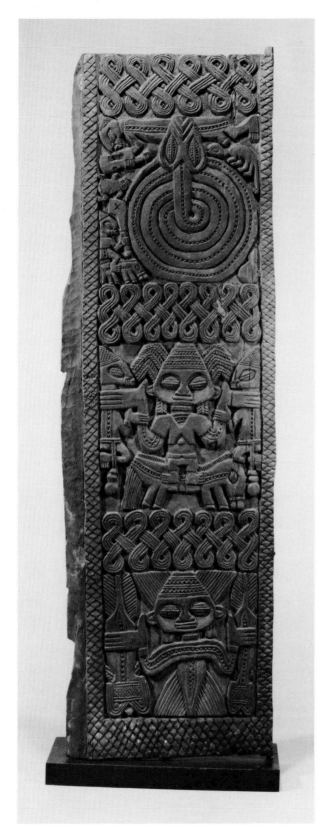

77
Ogboni Society, Yoruba Peoples, Nigeria
Door in Three Registers
wood
59 3/4 x 18 1/2 x 1 1/2 (151.8 x 47 x 3.8)
Michael Myers and Dr. H. Russell Albright Collection

Equatorial Forest

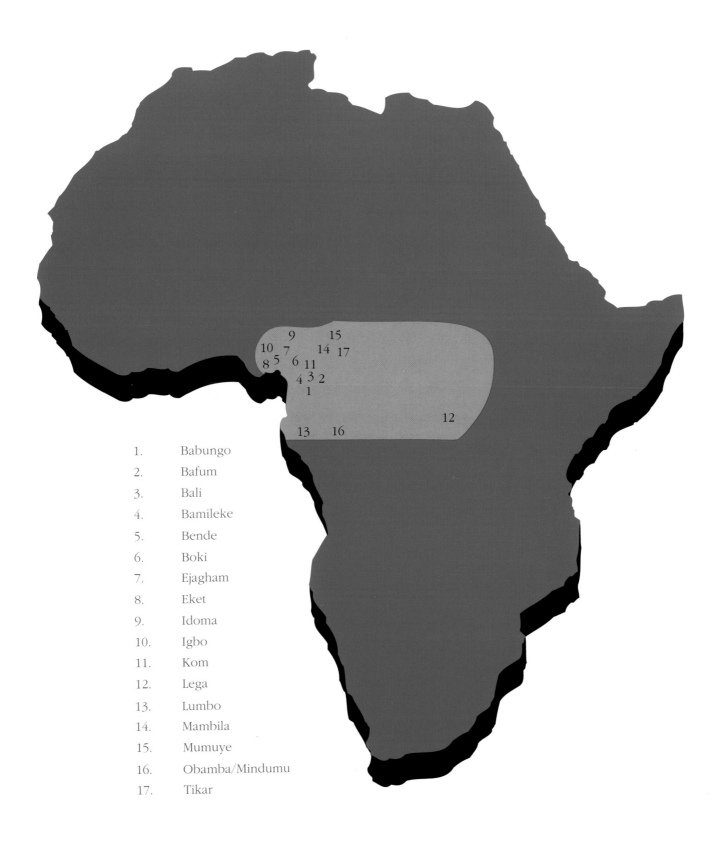

1. Babungo
2. Bafum
3. Bali
4. Bamileke
5. Bende
6. Boki
7. Ejagham
8. Eket
9. Idoma
10. Igbo
11. Kom
12. Lega
13. Lumbo
14. Mambila
15. Mumuye
16. Obamba/Mindumu
17. Tikar

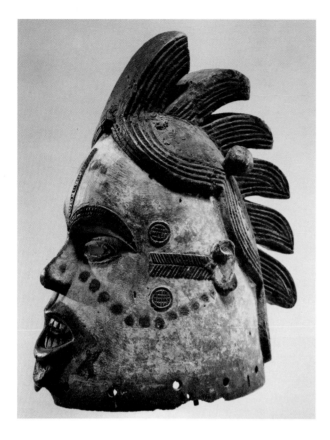

78
Igbo Peoples, Nigeria
Cap Mask
wood, pigment, mirror
9 1/2 x 6 1/8 x 7 7/8 (24.2 x 15.5 x 20)
Robert Gordy Collection (bequeathed to
the New Orleans Museum of Art in 1987)

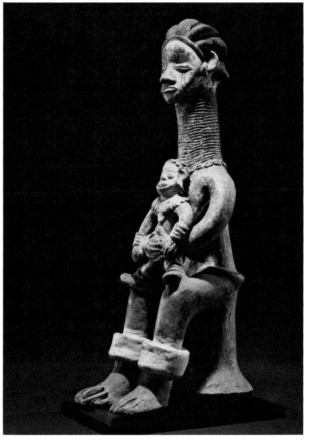

79
Igbo Peoples, Nigeria
Maternity Figure (*ntekpe*)
terracotta, pigment
20 1/2 x 6 1/8 x 8 1/4 (52.1 x 15.5 x 21)
Ida and Hugh Kohlmeyer Collection

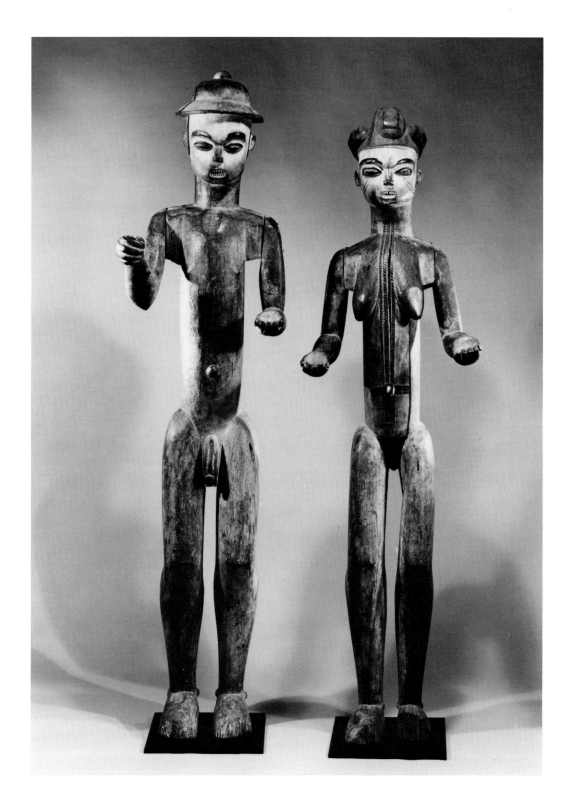

80
Igbo Peoples, Abakaliki Region, Nigeria
Standing Man and Woman Shrine Figures
wood, pigment, iron
male 66 x 16 1/2 x 20 1/2 (167.1 x 41.9 x 52.1)
female 63 1/2 x 18 1/8 x 15 (160 x 46 x 38.1)
Joni and Richard Watson Collection

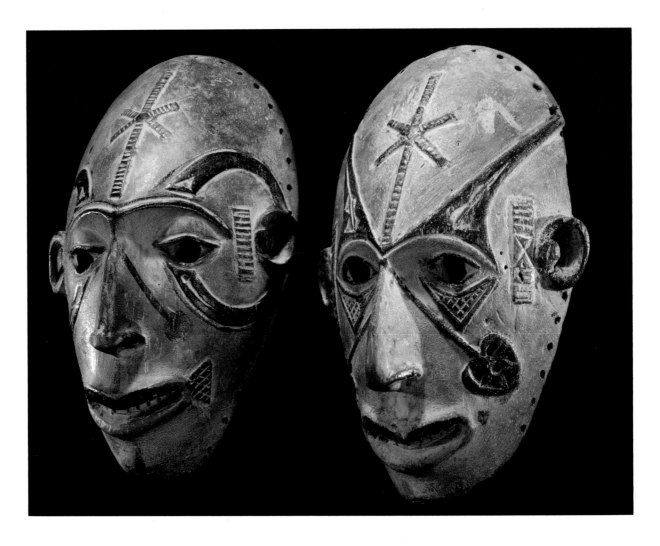

81
Igbo Peoples, Nigeria
Pair of Female Spirit Face Masks (*mmwo*)
wood, pigment, kaolin
8 3/8 x 5 1/4 x 4 (21.3 x 13.4 x 10.2)
8 1/4 x 5 1/4 x 3 7/8 (21 x 13.4 x 9.8)
Mr. and Mrs. J. Thomas Lewis Collection

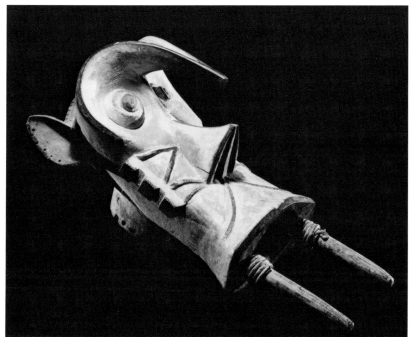

82
Igbo Peoples, Abakaliki Region, Nigeria
Elephant Mask (*ogbodo enyi*)
wood, pigment, kaolin, copper
11 7/8 x 25 3/4 x 10 1/2
(30.2 x 65.4 x 26.6)
Allison and Kenneth McAshan Collection

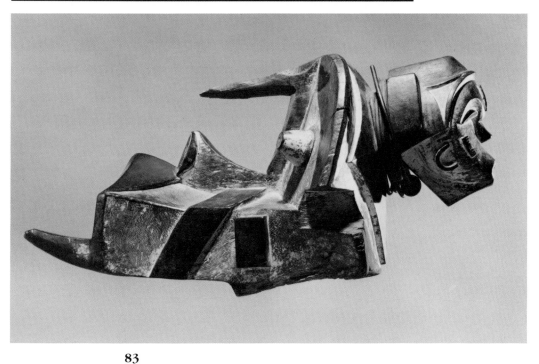

83
Igbo Peoples, Nigeria
Elephant Mask with Head (*ogbodo enyi*)
wood, pigment, iron, coins
13 3/4 x 12 1/4 x 24 1/2 (35 x 31.1 x 62.3) .
Robert Gordy Collection (bequeathed to the New Orleans
Museum of Art in 1987 in memory of Frank Kennett)

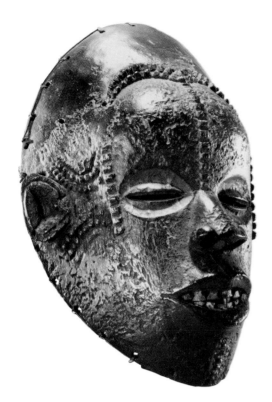

84
Idoma Peoples, Middle Cross River Region, Nigeria
Face Mask (*okua*)
wood, caning
8 3/4 x 6 3/4 x 4 3/4 (22.2 x 17.2 x 12.1)
Mr. and Mrs. J. Thomas Lewis Collection

85
Idoma Peoples, Nigeria
Male and Female Face Masks
wood, pigment, cloth, raffia, metal
male 11 x 6 3/4 x 7 (28 x 17.2 x 17.8)
female 10 x 7 1/2 x 6 3/4 (25.4 x 19 x 17.2)
Barbara and Wayne Amedee Collection

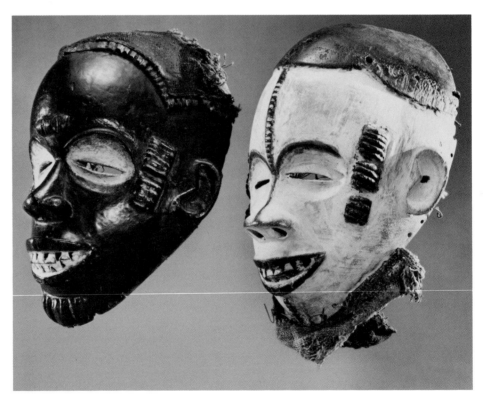

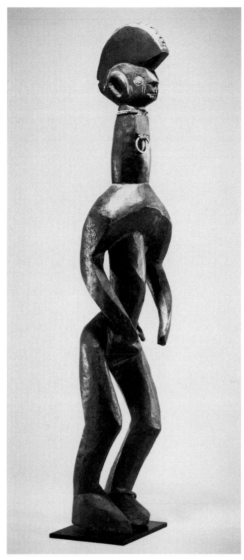

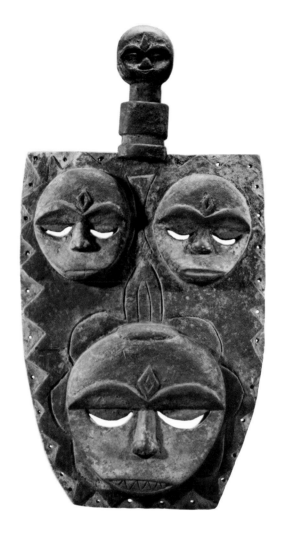

86
Mumuye Peoples, Nigeria
Standing Man
wood, brass, aluminum, leather, glass beads
29 1/2 x 6 x 6 (74.9 x 15.2 x 15.2)
Ida and Hugh Kohlmeyer Collection

87
Eket Peoples, Nigeria
Plank Mask
wood, pigment
25 3/4 x 13 1/2 x 2 1/4 (65.4 x 34.3 x 5.7)
Mr. and Mrs. J. Thomas Lewis Collection

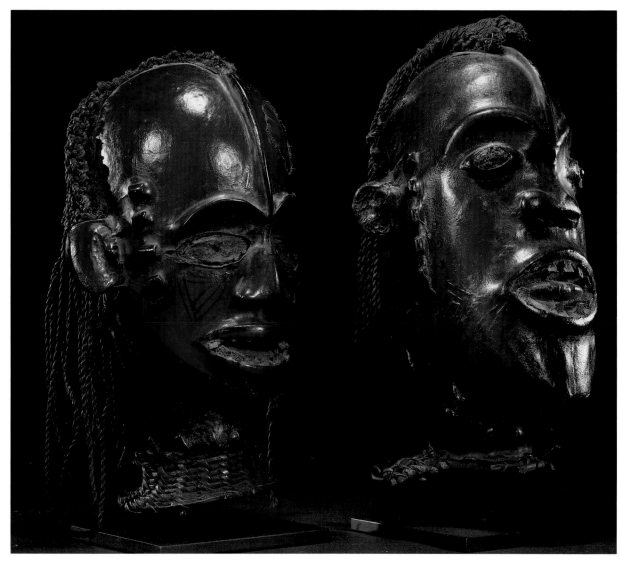

88

Ejagham or Boki Peoples, Cross River Region, Nigeria/Cameroon

Pair of Male and Female Cap Headdresses

wood, woven fibre, animal skin, cane basketry, iron
male 9 5/8 x 6 1/4 x 5 1/4 (24.5 x 15.8 x 13.4)
female 9 3/4 x 5 1/4 x 5 1/2 (24.8 x 13.4 x 14)
Joni and Richard Watson Collection

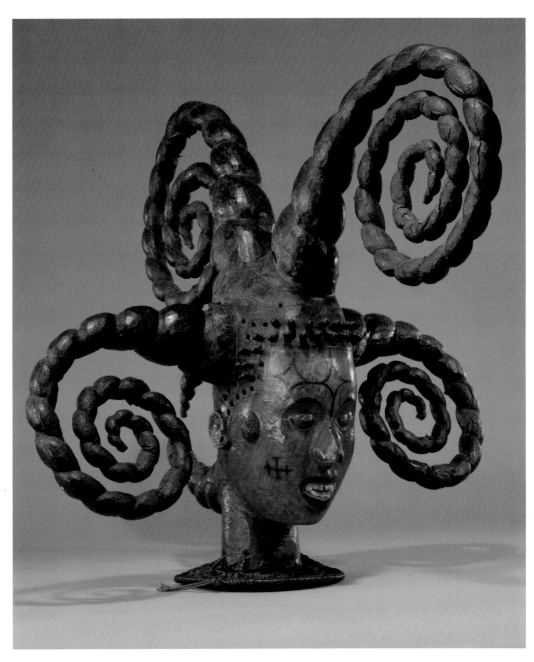

89
Ejagham Peoples, Cross River Region, Nigeria/Cameroon
Cap Headdress
wood, animal skin, cloth, lead, pigment, basketry
21 1/4 x 23 1/2 x 26 (54 x 59.7 x 66)
Jane and Henry Lowentritt Collection

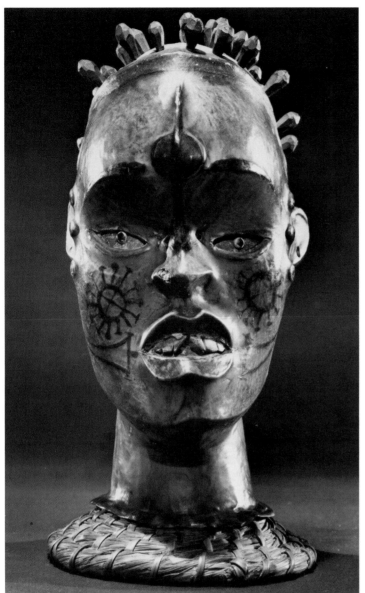

91
Ejagham Peoples, Cross River Region,
Nigeria/Cameroon
Cap Headdress
wood, animal skin, basketry
6 1/2 x 7 x 18 1/2 (16.5 x 17.8 x 47)
Nancy Stern Collection

90
Ejagham Peoples, Cross River Region, Nigeria/Cameroon
Cap Headdress
head, animal skin, pigment, basketry
12 1/4 x 6 1/2 x 7 (31.1 x 16.5 x 17.8)
Ida and Hugh Kohlmeyer Collection

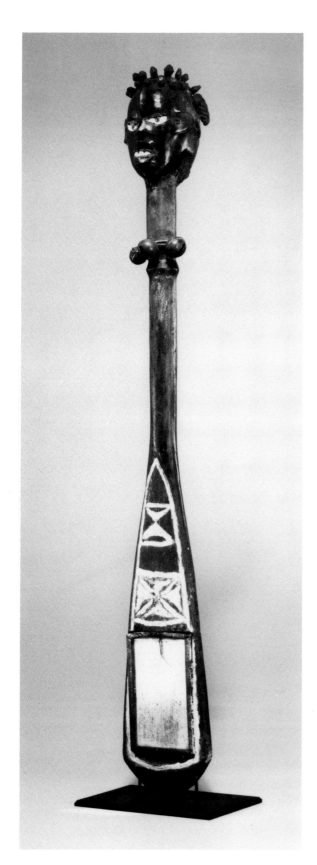

92
Ejagham Peoples, Cross River Region,
Nigeria/Cameroon
Janus Dance Staff
wood, leather, mirror, brass bells, iron nails,
organic ochres
30 1/2 x 4 3/4 x 3 1/2 (77.5 x 12.1 x 8.9)
Ida and Hugh Kohlmeyer Collection

93
Bende Peoples, Cross River Region,
Nigeria/Cameroon
Headcrest
wood, leather, kaolin, iron, raffia, cotton
19 x 5 1/2 x 7 1/2 (48.2 x 14 x 19)
Ida and Hugh Kohlmeyer Collection

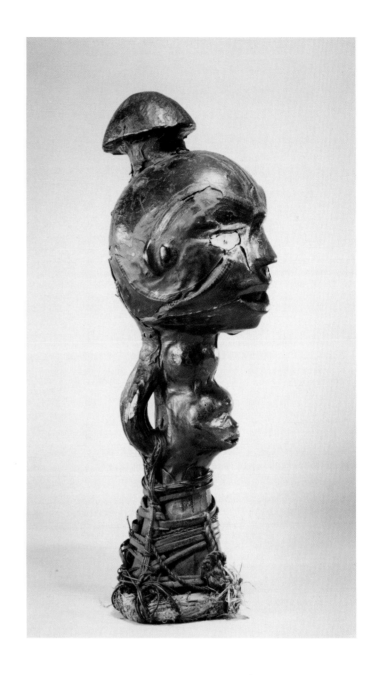

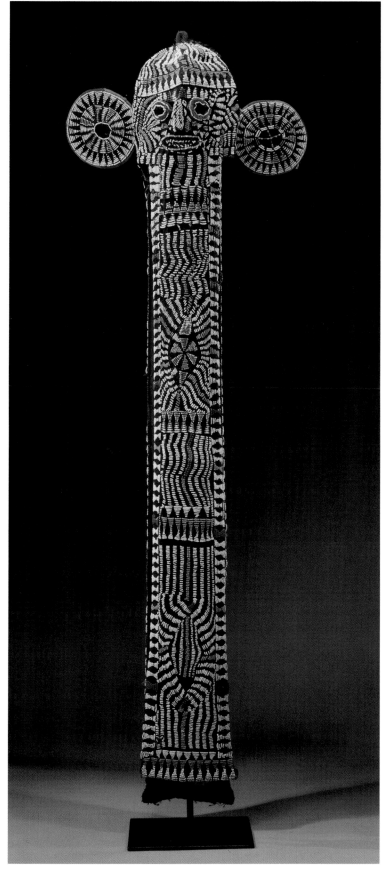

94
Kuosi Society, BamilekePeoples, Cameroon
Elephant Mask
cloth, glass beads
58 1/4 x 23 x 13 (148 x 58.4 x 33)
Polly and Edward Renwick Collection

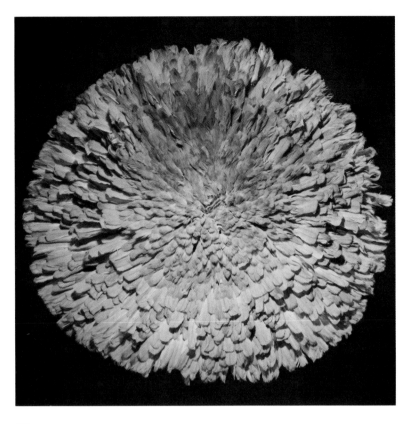

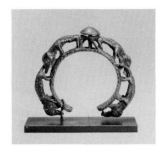

96
Babungo Kingdom, Cameroon
Royal Bracelet with Four Rodents
brass
3 1/4 x 7/8 x 3 3/4 (8.2 x 2.2 x 9.5)
Nancy Stern Collection

95
Bamileke Peoples, Cameroon
Headcrest
feathers, cloth, fibre, string
29 x 28 x 9 (73.7 x 71.2 x 22.9)
Ann Wilkinson Collection
cover illustration detail

97
Bali Kingdom, Bamenda Region, Cameroon
Elephant Helmet Mask
wood, pigment
11 x 44 1/2 x 12 3/4 (28 x 113 x 32.4)
Dr. John Finley Collection

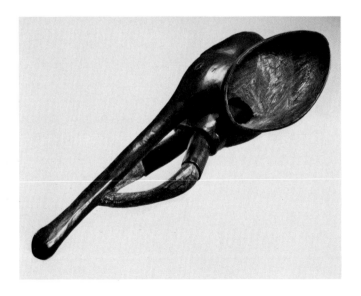

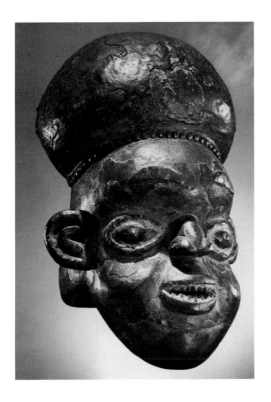

98
Kom Kingdom, Cameroon
Helmet Mask
wood, brass tacks, string, pigment
16 X 10 X 9 (40.6 x 25.4 x 22.9)
Jane and Henry Lowentritt Collection

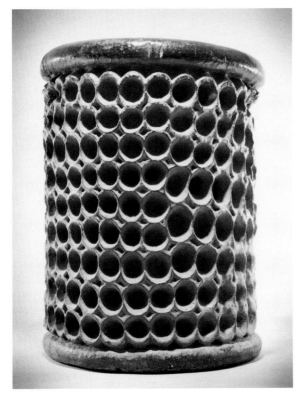

99
Kom Kingdom, Cameroon
Stool
wood, red powder, brass
19 1/2 x 15 1/2 diameter (49.5 x 39.4 diameter)
Barbara and Wayne Amedee Collection

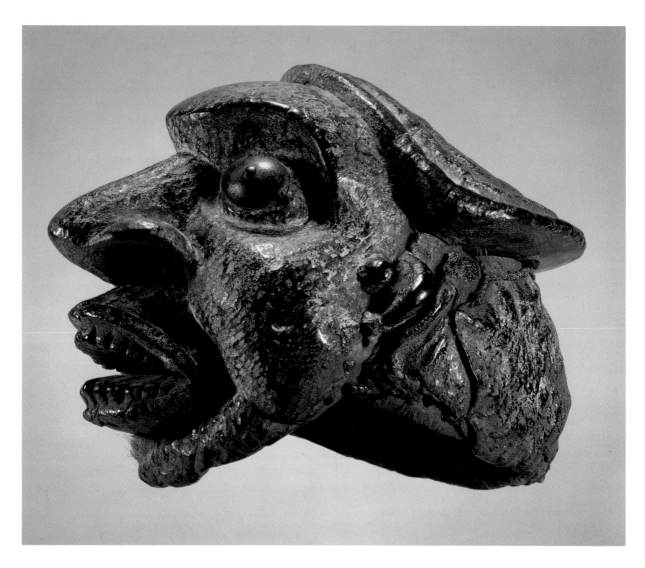

100
Bafum or Fungom Peoples,
Kingdom of Wum, Cameroon
Helmet Mask
wood, iron, leather, camwood powder
9 x 9 x 11 (22.9 x 22.9 x 28)
Kent and Charles Davis Collection

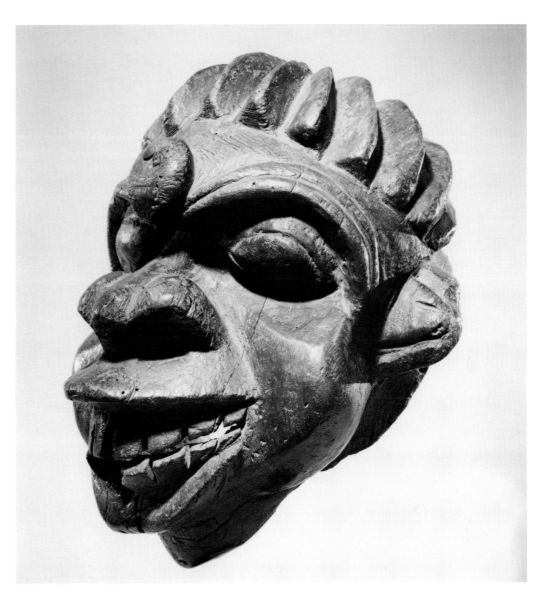

101
Bafum or Fungom Peoples,
Kingdom of Wum, Cameroon
Face Mask (*mabwo*)
wood
14 x 10 3/4 x 7 7/8 (35.6 x 27.3 x 20)
Katherine and Richard Buckman
Collection

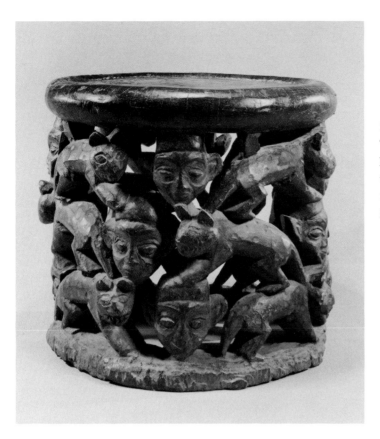

102
Tikar Peoples, Cameroon
Royal Stool
wood
13 1/2 x 15 diameter (34.3 x 38.1 diameter)
Minnie and James Coleman, Jr. Collection

103
Tikar Peoples, Cameroon
Smoking Pipe
bronze, wood
30 1/4 x 2 1/2 (76.8 x 6.4)
Mr. and Mrs. Pierre de La Barre Collection

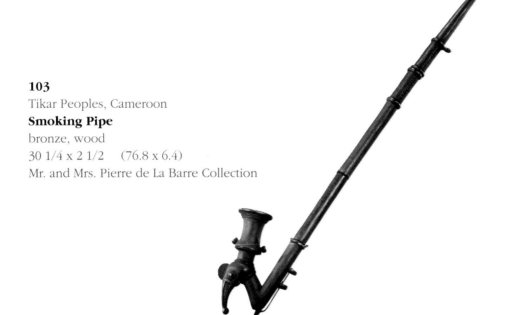

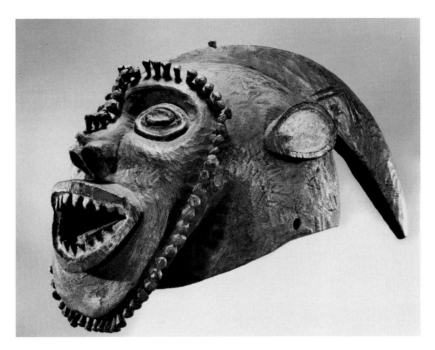

104
Mambila Peoples, Cameroon
Anthropomorphic Hunter Mask
wood, organic ochres, kaolin
9 x 10 x 15 (22.9 x 25.4 x 38.1)
Mr. and Mrs. J. Thomas Lewis Collection

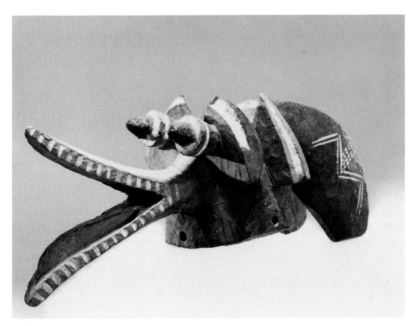

105
Mambila Peoples, Cameroon
Crow Mask
wood, organic ochres
6 x 4 x 12 (15.2 x 10.2 x 30.5)
Nancy Stern Collection

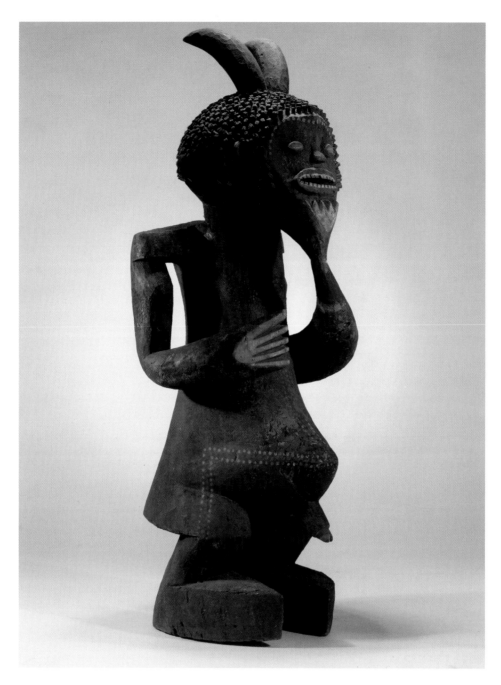

106
Mambila Peoples, Cameroon
Male Ancestor Figure (*tadep*)
wood, organic ochres
30 1/2 x 11 x 10 1/2 (77.5 x 28 x 26.6)
Anonymous Collection

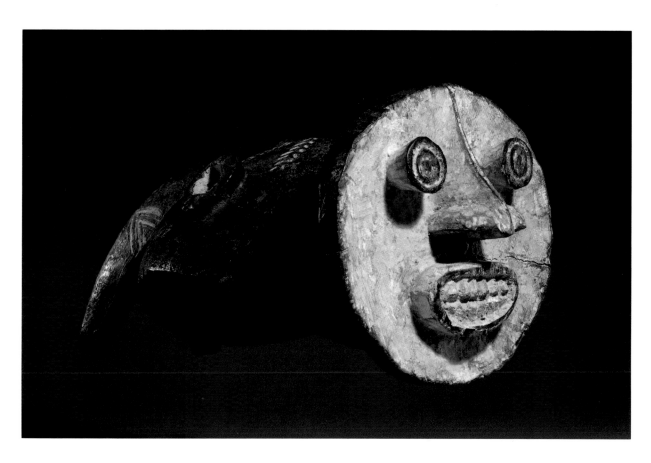

107
Mambila Peoples, Cameroon
Anthropomorphic Hunter Mask
wood, organic ochres
9 x 9 x 15 (22.9 x 22.9 x 38.1)
Carol and Dr. George Harell Collection

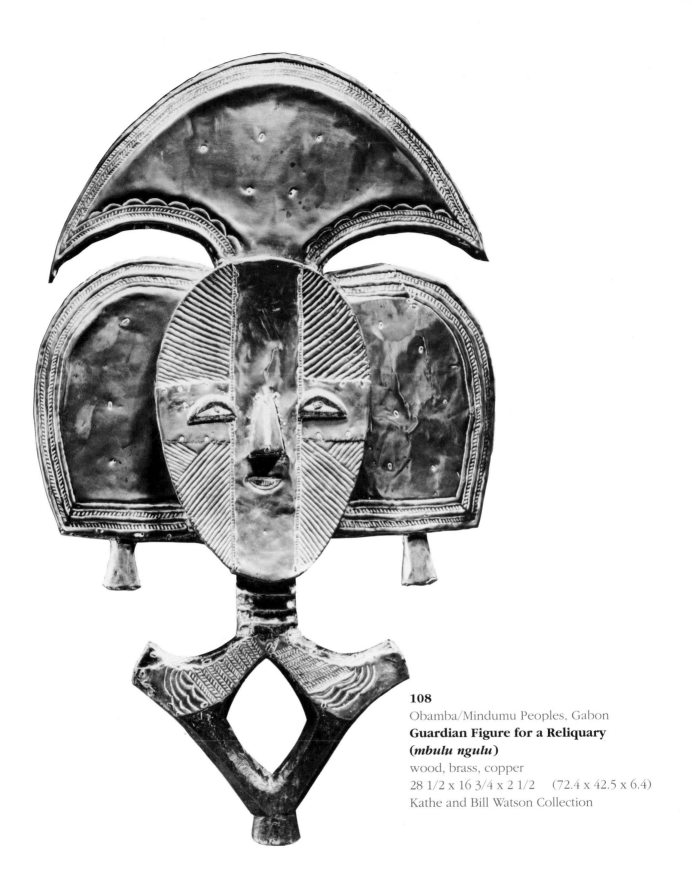

108
Obamba/Mindumu Peoples, Gabon
Guardian Figure for a Reliquary
(***mbulu ngulu***)
wood, brass, copper
28 1/2 x 16 3/4 x 2 1/2 (72.4 x 42.5 x 6.4)
Kathe and Bill Watson Collection

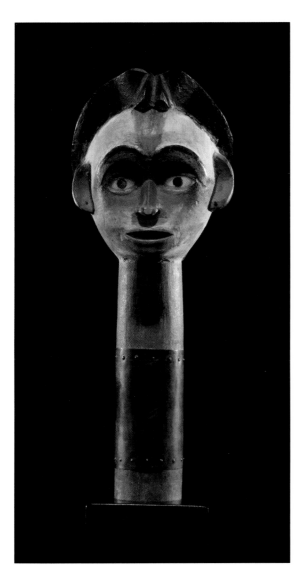

109
Lumbo Peoples, Gabon
Reliquary Head
wood, copper, glass, pigment
17 x 4 3/4 x 4 1/4 (43.2 x 12.1 x 10.8)
Ida and Hugh Kohlmeyer Collection

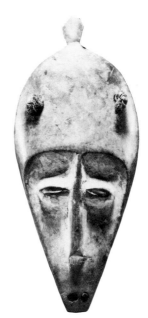

111
Lega Peoples, Zaire
Miniature Mask
wood, twisted vegetable
fibre, kaolin
6 1/4 x 2 3/4 x 1 1/4
(15.8 x 7 x 3.2)
Ida and Hugh
Kohlmeyer Collection

110
Lega Peoples, Zaire
**Standing Woman
(*lutumbo iwa kindi*)**
ivory
6 1/4 x 2 x 1 5/8
(15.8 x 5.1 x 4.1)
Nancy Stern Collection

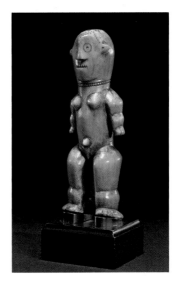

Southern Savannah

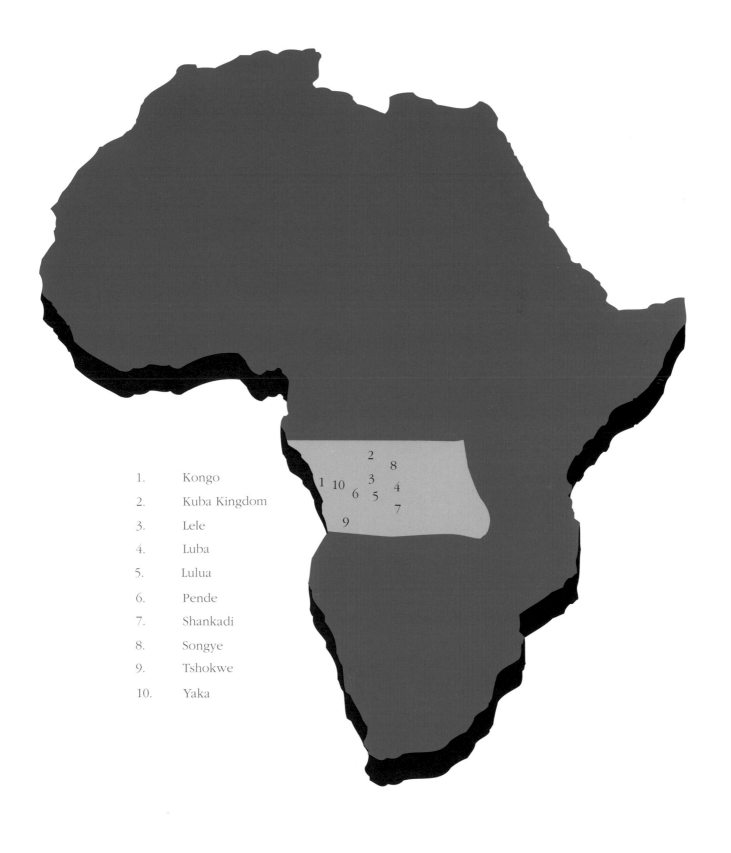

1. Kongo

2. Kuba Kingdom

3. Lele

4. Luba

5. Lulua

6. Pende

7. Shankadi

8. Songye

9. Tshokwe

10. Yaka

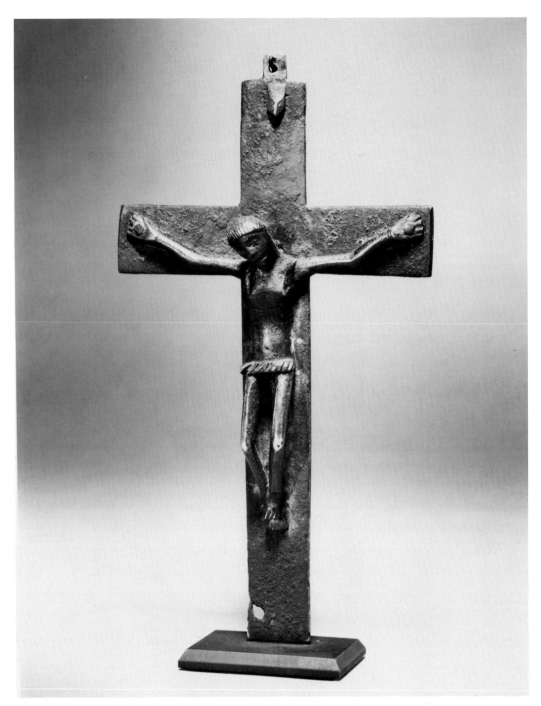

112
Kongo Peoples, Zaire
Crucifix (*nkangi* or *nkangi kiditu*)
bronze
9 x 5 x 1 (22.9 x 12.7 x 2.5)
Drs. Jane and William Bertrand Collection

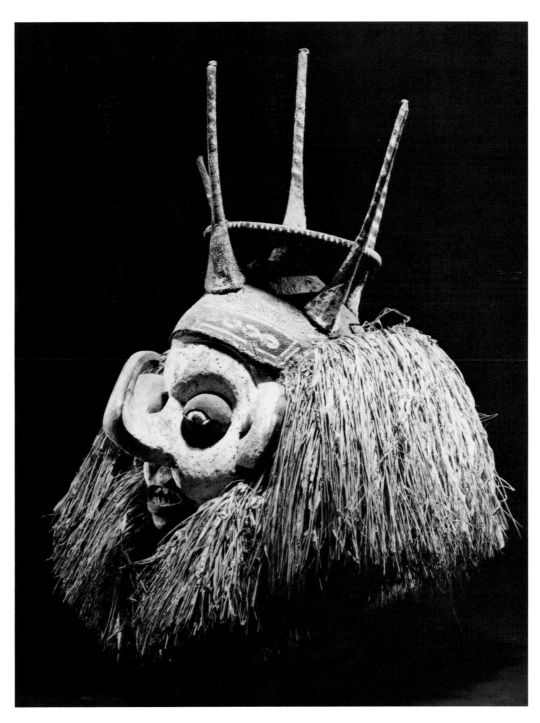

113
Yaka Peoples, Kwango-Kwilu Region, Zaire
Face Mask (*ndemba* or *nkanda*)
wood, fibre, pigment
23 x 17 x 15 (58.7 x 43.2 x 38.1)
Anonymous Collection

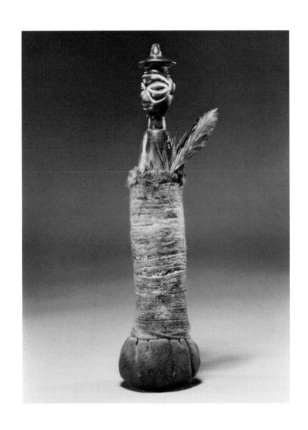

114
Yaka Peoples, Kwango-Kwilu Region, Zaire
Fetish Figure
wood, kaolin, string, cloth, feathers
5 1/2 x 1 1/4 x 1 1/4 (14 x 3.2 x 3.2)
Mr. and Mrs. J. Thomas Lewis Collection

115
Pende Peoples, Kwango-Kwilu Region, Zaire
Face Mask (*giwoyo* or *kiwoyo-muyombo* of *mbuya* type)
wood, fibre, pigment
31 1/2 x 10 x 11 1/2 (80 x 25.4 x 29.2)
Ida and Hugh Kohlmeyer Collection

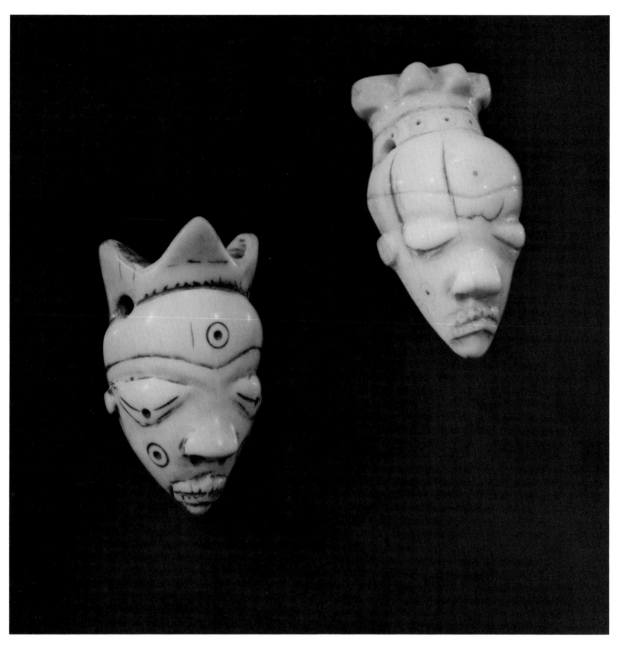

116
Pende Peoples, Kwango-Kwilu Region, Zaire
**Pendant in Form of Miniature Mask
(*ikhoko*)**
ivory
2 1/4 x 1 1/4 x 3/4 (5.7 x 3.2 x 2)
Mr. and Mrs. J. Thomas Lewis Collection

117
Pende Peoples, Kwango-Kwilu Region, Zaire
**Pendant in Form of Miniature Mask
(*ikhoko*)**
ivory
2 3/8 x 1 1/8 x 1 1/8 (6 x 2.8 x 2.8)
1 1/2 x 1 1/8 x 3/4 (3.8 x 2.8 x 2)
Gene Willett Collection

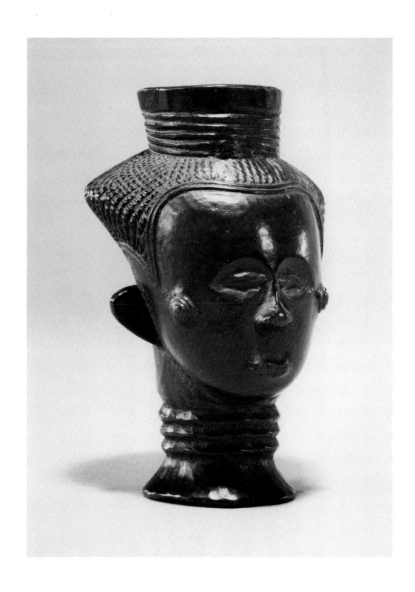

118
Lele Peoples, Zaire
Cephalic Drinking Cup
wood
5 1/2 x 3 1/2 x 3 1/2 (14 x 8.9 x 8.9)
Ida and Hugh Kohlmeyer Collection

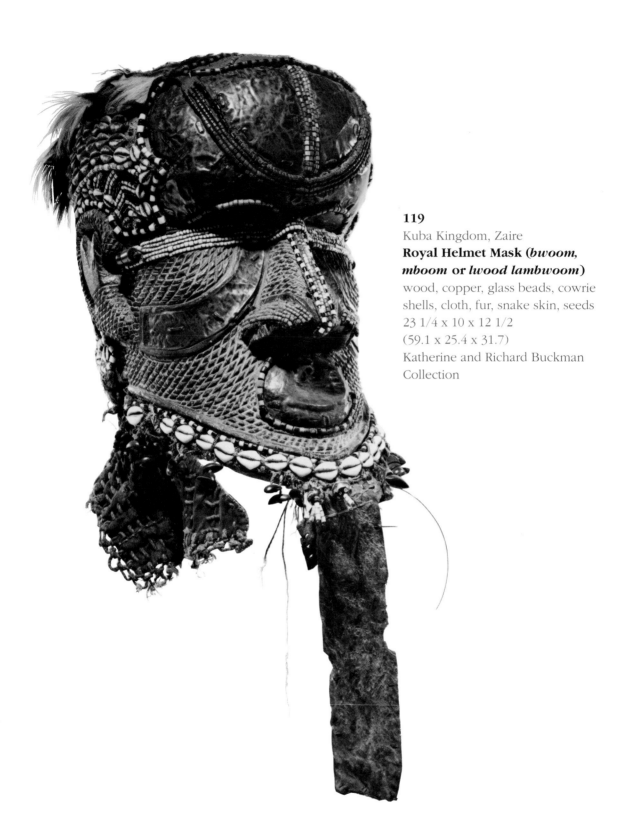

119
Kuba Kingdom, Zaire
Royal Helmet Mask (*bwoom, mboom* or *lwood lambwoom*)
wood, copper, glass beads, cowrie shells, cloth, fur, snake skin, seeds
23 1/4 x 10 x 12 1/2
(59.1 x 25.4 x 31.7)
Katherine and Richard Buckman Collection

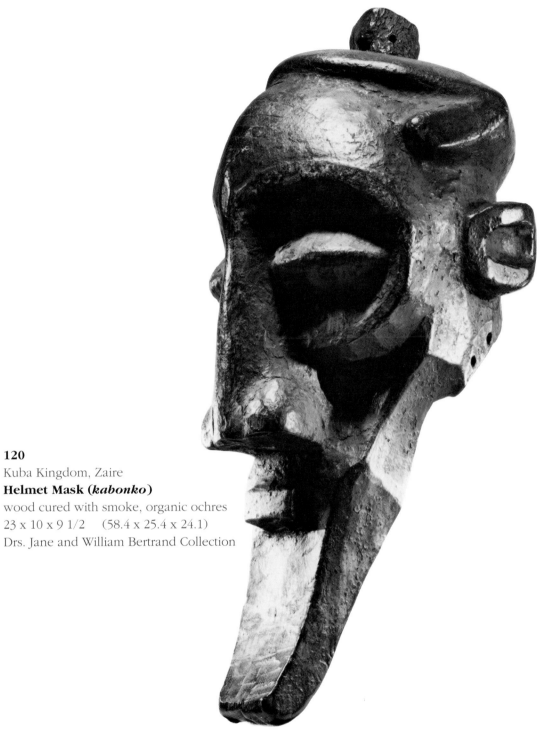

120
Kuba Kingdom, Zaire
Helmet Mask (*kabonko*)
wood cured with smoke, organic ochres
23 x 10 x 9 1/2 (58.4 x 25.4 x 24.1)
Drs. Jane and William Bertrand Collection

121
Lulua Peoples, Zaire
Face Mask
wood, organic ochres, iron
13 1/2 x 8 x 7 (34.3 x 20.3 x 17.8)
Kathe and Bill Watson Collection

122
Shankadi Peoples, Zaire
Kneeling Woman with Bowl (*kabila, luboko* or *mboko*)
wood, animal horn, aluminum, tin
12 1/2 x 5 x 5 1/4 (31.7 x 12.7 x 13.4)
Nancy Stern Collection

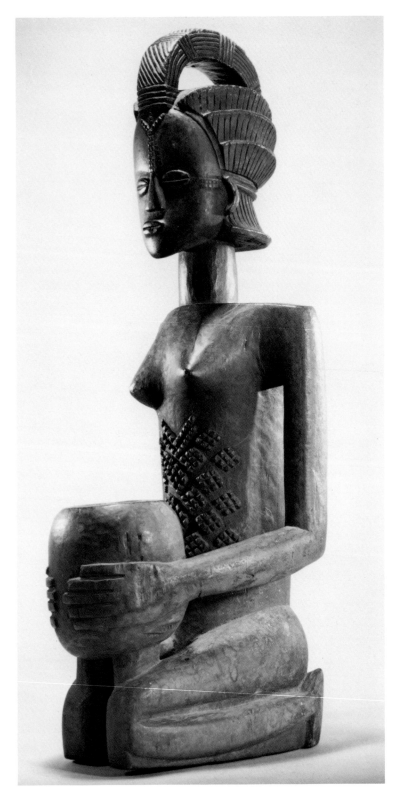

123
Shankadi Peoples, Zaire
Master of Sungu, carver
Kneeling Woman with Bowl
(***kabila, luboko* or *mboko***)
wood
20 x 6 1/2 x 7 1/2 (50.8 x 16.5 x 19)
Nancy Stern Collection

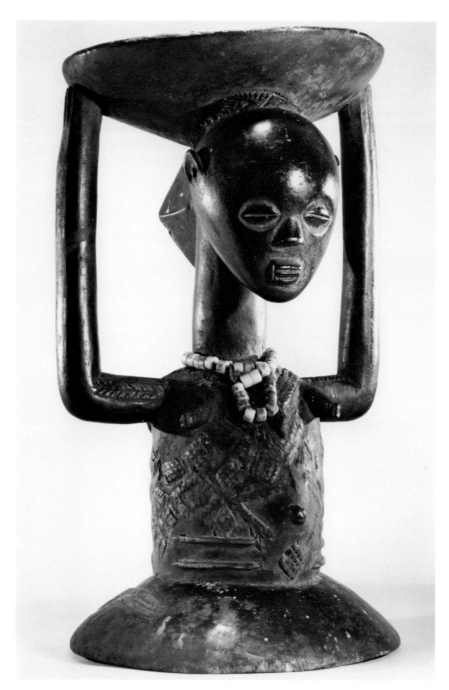

124
Eastern Luba Peoples, Zaire
Master of Mwanza, carver
Caryatid Stool (*kipona*)
wood, glass beads, string
20 1/4 x 12 1/2 x 11 (51.4 x 31.7 x 28)
Nancy Stern Collection

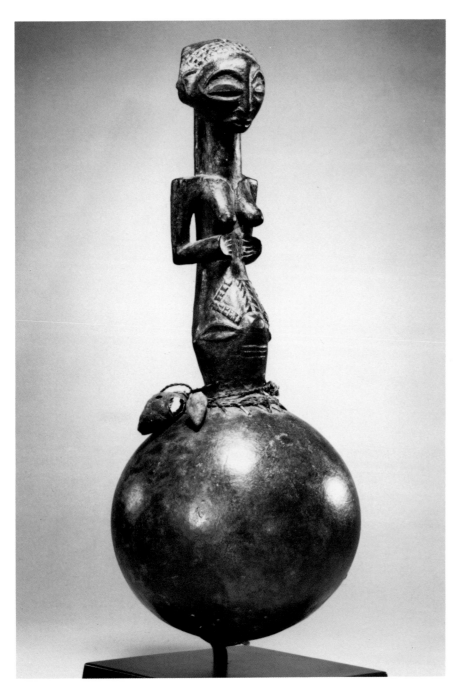

125
Buhabo Society, Eastern Luba or Hemba Peoples, Zaire
Divination Figure (*mabwe lugullu*)
wood, calabash, cowrie shells, string, caning
14 x 5 7/8 diameter (35.6 x 15 diameter)
Luba B. Glade Collection

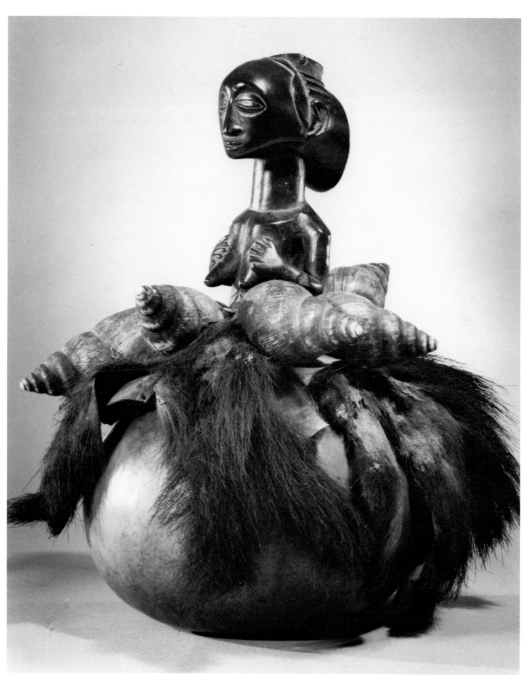

126
Buhabo Society, Eastern Luba Peoples, Zaire
Divination Figure (*mabwe lugullu*)
wood, calabash, monkey fur, cowrie shells
11 x 7 7/8 x 8 1/2 (28 x 20 x 21.6)
Kathe and Bill Watson Collection

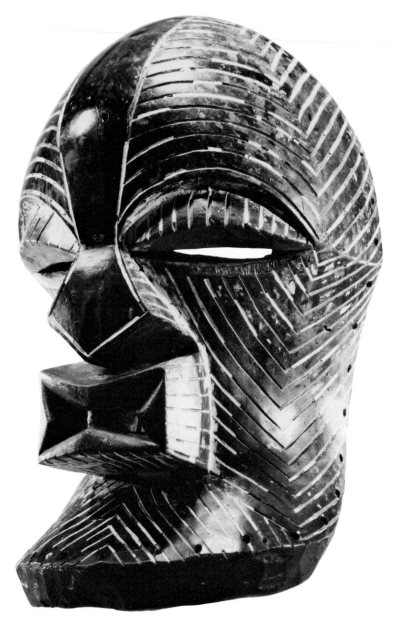

127
Songye Peoples, Zaire
Face Mask (*tshifwebe* or *kifwebe*)
wood, kaolin, pigment
13 3/4 x 9 x 7 1/4 (35 x 22.9 x 18.5)
Joni and Richard Watson Collection

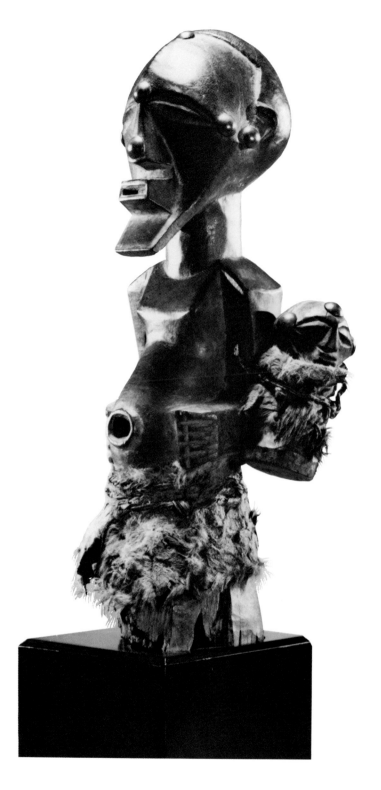

128
Songye Peoples, Zaire
Man with Attached Figurative Charm
wood, brass tacks, animal skin, rawhide, fur
12 1/8 x 5 3/4 x 3 1/2 (30.7 x 14.6 x 8.9)
Ida and Hugh Kohlmeyer Collection

129
Tshokwe Peoples, Angola
Chief's Chair
wood, carpet tacks, leather
36 1/2 x 12 3/4 x 15
(92.7 x 32.4 x 38.1)
Nancy Stern Collection

Selected Bibliography

Bravmann, René A. *African Islam.* Washington, D.C.: Smithsonian Institution Press, 1983.

Cole, Herbert M., and Chike C. Aniakor. *Igbo Arts: Community and Cosmos.* Los Angeles: University of California, Museum of Cultural History, 1984.

Cole, Herbert M., and Doran H. Ross. *The Arts of Ghana.* Los Angeles: University of California, Museum of Cultural History, 1977.

Cornet, Joseph. *Art of Africa: Treasures from the Congo.* Brussels: Editions Arcade, 1971. Translated by Barbara Thompson. London: Phaidon Press Limited, 1971.

de Grunne, Bernard. *Terres Cuites Anciennes de L'Ouest Africain/Ancient Terracottas from West Africa.* Louvain-La-Neuve: Institut Superieur d'Archeologie et d'Histoire d'Art, 1980.

Elisofon, Eliot. *La Sculpture Africaine.* London: Thames and Hudson, 1958.

Eyo, Ekpo. *Two Thousand Years Nigerian Art.* Lagos: Federal Department of Antiquities, 1977.

Eyo, Ekpo, and Frank Willet. *Treasures of Ancient Nigeria.* New York: Alfred A. Knopf in association with Detroit Institute of Art, 1980.

Ezra, Kate. *Art of the Dogon: Selections from the Lester Wunderman Collection.* New York: Metropolitan Museum of Art, 1988.

Fagg, William, and John Pemberton. *Yoruba Sculpture of West Africa.* Edited by Bryce Holcombe. New York: Alfred A. Knopf, 1982.

Fagg, William, and Margaret Plass. *African Sculpture: An Anthology.* London: Studio Vista Limited, 1964.

Felix, Marc Leo. *100 Peoples of Zaire and Their Sculpture.* Brussels: Tribal Arts Press, Brussels, 1987.

Fischer, Eberhard, and Hans Himmelheber. *The Arts of the Dan in West Africa.* Translated by Ann Bundle. Zurich: Museum Rietberg, 1984.

Gilfoy, Peggy Stoltz. *Patterns of Life: West African Strip-Weaving Traditions.* Washington, D.C.: National Museum of African Art, Smithsonian Institution Press, 1987.

Gillon, Werner. *Collecting African Art.* New York: Rizzoli International Publications, Inc., 1980.
————. *A Short History of African Art.* New York: Viking Penguin Inc., 1984.

Goldwater, Robert. *Bambara Sculpture from the Western Sudan.* New York: University Publishers for the Museum of Primitive Art, 1964.

————. *Senufo Sculpture from West Africa*. Greenwich: New York Graphic Society for the Museum of Primitive Art, 1964.

Johnson, Barbara C. *Four Dan Sculptors: Continuity and Change*. San Francisco: The Fine Arts Museum of San Francisco, 1986.

Northern, Tamara. *The Art of Cameroon*, Washington, D.C.: Smithsonian Institution Traveling Exhibition Service, 1984.

Roy, Christopher D. *Art and Life in Africa: Selections from the Stanley Collection*. Iowa City: The University of Iowa Museum of Art, 1985.

Rubin, Arnold. *African Accumulative Sculpture: Power and Display*. New York: The Pace Gallery, 1974.

Rubin, William, ed. *"Primitivism" in 20th Century Art: Affinity of the Tribal and the Modern*. 2 vols. New York: Museum of Modern Art, 1984.

Sieber, Roy. *Sculpture of Northen Nigeria*. New York: Museum of Primitive Art, 1961
————. *African Textiles and Decorative Arts*. New York: Museum of Modern Art, 1972.
————. *African Furniture and Household Objects*. Bloomington: Indiana University Press, 1980.

Sieber, Roy, and Arnold Rubin. *Sculpture of Black Africa: The Paul Tishman Collection*. Los Angeles: Los Angeles County Museum of Art, 1968.

Sieber, Roy, and Roslyn Adele Walker. *African Art in the Cycle of Life*. Washington, D.C.: Smithsonian Institution Press for the National Museum of African Art, 1987.

Sweeney, James Johnson, ed. *African Negro Art*. New York: The Museum of Modern Art, 1935, reprint Arno Press, 1966.

Thompson, Robert Farris. *African Art in Motion: Icon and Art in the Collection of Katherine Coryton White*. Los Angeles: University of California Press, 1974.
————. *Black Gods and Kings*. Bloomington: Indiana University Press, 1976.

Vogel, Susan Mullin. *African Aesthetics: The Carlo Monzino Collection*. Venice: Abbazia di S. Gregorio, 1985.

Vogel, Susan, and Francine N'Diaye. *African Masterpieces from the Musée de l'Homme*. New York: Center for African Art and Harry N. Abrams, Inc., 1985.

Vogel, Susan, ed. *For Spirits and Kings: African Art from the Paul and Ruth Tishman Collection*. New York: Metropolitan Museum of Art, 1981.

Willet, Frank. *African Art*. New York: Praeger Publishers, 1971.

Index of Peoples, Cultures, and Kingdoms

numbers refer to catalogue entries